NORTHERN CANALS

Lancaster, Ulverston, Carlisle
& the Pennine Waterways

THROUGH TIME

Ray Shill

AMBERLEY PUBLISHING

First published 2014

Amberley Publishing
The Hill, Stroud, Gloucestershire, GL5 4EP
www.amberley-books.com

Copyright © Ray Shill, 2014

The right of Ray Shill to be identified as the
Author of this work has been asserted in accordance with
the Copyrights, Designs and Patents Act 1988.

ISBN 978 1 4456 3319 0 (print)
ISBN 978 1 4456 3333 6 (ebook)

British Library Cataloguing in Publication Data.
A catalogue record for this book is available from the
British Library.

Typesetting by Amberley Publishing.
Printed in Great Britain.

Contents

Introduction

Waterway construction through the North of England was handicapped by terrain, and those engineers and navvies who built the canals in this region faced the extremes of British weather. The challenges that were presented in the making of these navigations proved formidable. Yet, three waterways were made across the Pennines to link the North West coast with the North East coast. These were the Huddersfield (Narrow), Leeds & Liverpool and the Rochdale. All of these routes passed through scenic locations.

An equal challenge was the Lancaster that united the coal mines near Wigan with Preston, Lancaster and Kendal. This canal wound its way northwards to Tewitfield before eight locks were required to raise the waterway to the level section to Kendal.

Established industry was often the reason for waterway construction and development. For the Pennine waterways, a primary reason was the spinning of cotton or wool. These provided important business for the region. It was one initially based on the water mill, which drew its power from the turning of the water wheel. Those engaged in such trade jealously guarded their water supply and any attempts to divert it to supply canals were frequently resisted. Yet a compromise was reached where navigation water supply for the canals was stored in groups of reservoirs high up near the watershed.

There were several other schemes that promised inland navigation across these parts that came to nothings. Cumberland and Westmorland had rivers that were scarcely navigable beyond the coast. Only the Eden provided safe navigation inland towards Carlisle and the coalfield near Maryport.

Chapter One
Waterways Along the Coast
Carlisle, Lancaster (North), Ribble and Ulverston

The Lancaster Canal was a canal of two halves, separated by a tramway link across the Ribble. It united the coal fields near Wigan with Preston and Lancaster, although it was never completed to the authorised terminus of Westhoughton, near Wigan. Construction was also hampered by financial restraints. The two canal sections were first made from Kirklees (near Wigan) to Walton Summit (13¼ miles), and from Preston to Kendal (57 miles). The southern section was discussed in *North West Canals Through Time: Manchester, Irwell & the Peaks.* This book will look at the tram road and northern section, from Preston to Kendal.

Building the canal north from Preston was accomplished first as far as Tewitfield by November 1797. The extension to Kendal, which included eight locks at Tewitfield, did not commence until May 1817, but was completed at Kendal in 1819. A branch to Glasson Dock on the Lune estuary was opened in 1825. All locks on both the Kendal extension and Glasson Dock Branch were 72 feet long by 14 feet 6 inches wide, and enabled coastal craft such as sloops and flats to access the canal. It also provided a means for them to move goods between Preston, Liverpool and Manchester.

Water supply was improved for the northern section by the taking of water from the River Keer at Capernwray through a feeder into the canal. At Preston, a tunnel was constructed during 1806 that was cut through the rock to join the Ribble. Pumping water from the Ribble was done by a Boulton Watt steam engine.

Plans were proposed for the Lancaster Canal to have a navigable link with Ulverston. Whatever form of connection was planned, however, did not materialise. The Ulverston Canal (1½ miles long) had a sea lock that took craft 100 feet long by 12 feet 6 inches wide, and enabled seagoing craft to enter the canal and navigate to the wharves. The Ulverston Canal was opened during 1796. A principal cargo was the iron ore trade, for which there was a general demand. Water for the navigation came from Newland Beck.

The coast north of Ulverston had various inlets and ports that were also associated with the iron ore trade and coal mining. Principal ports included: Workington, Whitehaven, Harrington and Maryport. At Carlisle, the River Eden was navigable to Sandsfield and goods were transferred to road wagons there. An opportunity was taken to improve transport in this region with an ambitious scheme in mind for a canal to Newcastle-upon-Tyne via Carlisle, where William Chapman, engineer, had an input. Finally a simpler scheme for the navigation of the Solway Firth and a Ship Canal to Carlisle was adopted and this waterway was finished in 1823.

River navigations in the North West included the Ribble and the Lune. For the Ribble, various improvements were made during the nineteenth century. From 1826, rocks in the bed near the

Marsh Quay were removed for the Ribble Navigation Company and then for more ambitious schemes a decade later. In April 1834, engineer T. Fletcher, planned the Preston & Lytham Ship Canal. An alternative to a ship canal was the dredging of the river as suggested by engineers R. Stevenson & Son, of Edinburgh, in 1837. This formed the basis for the creation of a new Ribble Navigation Company and the passing of an act that enabled them to raise capital by share issue. Work went on during the late 1830s and early 1840s that led to the deepening of the river, creation of new wharves and warehouses and the establishment of Preston as a port.

The wharves occupied a stretch of land that extended southwards to the bottom of Fishergate and included boat building yards. A railway link was also made to these wharves that serviced the Victoria Warehouse and had loading shoots off the quayside. A more extensive improvement was left until the 1880s, when the Ribble was diverted to allow for a new, large dock – the Albert Edward Dock – to be constructed. This dock was ready by 1892, but it would be several years later that the warehouses around it were finished and the railway system completed. Another improvement was the making of New Diversion Quay on the altered river course, north of Penwortham Bridge, which was also served by a branch of the Dock Railway. This part of the river was also chosen for the building of Penwortham Power Station (1925).

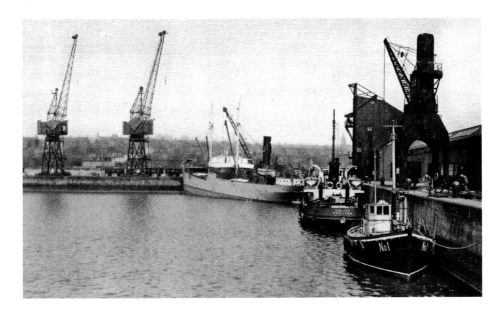

Preston Docks, River Ribble
The Albert Edward Dock was opened in 1892 and provided facilities for ships and other vessels that navigated the Ribble. The dock had warehouses aligned alongside the south quayside, and there was a railway owned by the Port of Preston that handled traffic for, and from, the national rail network. (*RCHS Postcard Collection 97291*)

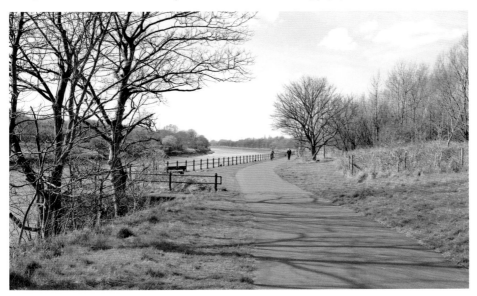

New Deviation Quay, Preston, River Ribble
During the 1840s, new wharves were constructed alongside the Ribble that were rail served and were also the location of a warehouse known as Victoria. The diversion of the Ribble, the filling in of the old course and the building of the new Albert Edward Docks (1885–92), were accompanied by the construction of a new long quay alongside the Ribble, which was served by the Port of Preston Dock Railway. On the opposite bank was the site of the Penwortham Power Station (1925). (*Ray Shill 836841*)

Preston Warehouse, Terminus Basin, Lancaster Canal
There was a warehouse that covered the side basin at Preston and had two loading bays for barges underneath. (*Heartland Press Collection 775204*)

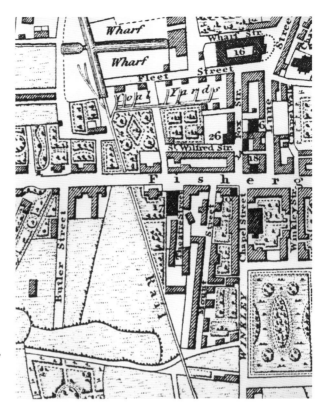

Preston Terminus Basin, Lancaster Canal, 1824
The Lancaster Canal tramway terminated alongside the wharves of the Lancaster Canal (North Section). The plateway branched out into several sidings, serving a coal wharf and the main basin. (*Heartland Press Collection 251005*)

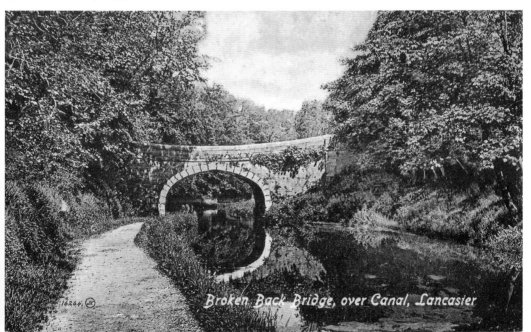

Broken Back Bridge, Lancaster Canal, c. 1905
One of the bridges near Lancaster was known as Broken Back. Its name initially matched its appearance. (*RCHS Postcard Collection 96431*)

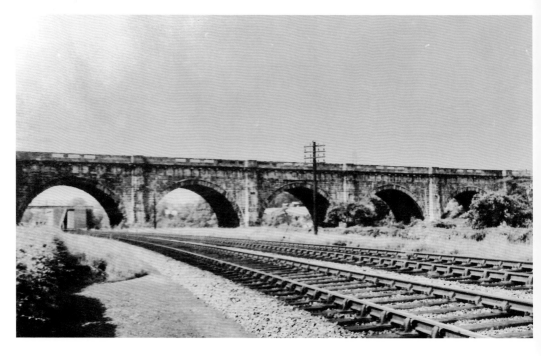

Lune Aqueduct, Lancaster Canal

John Rennie, the elder, was a very competent canal engineer. He was employed on canal schemes across the country. His skills, which have been preserved in stone, remain to this day on such diverse canals as the Kennett & Avon, the Trent & Mersey and the Lancaster. The five-arch aqueduct crossed the River Lune at Lancaster. Later, one of these arches was used to span the 'Little' North Western Railway line. (*Above: RCHS Hugh Compton Collection 64942. Below: Ray Shill 775855*)

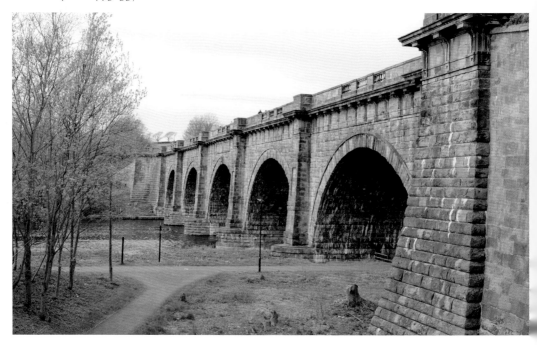

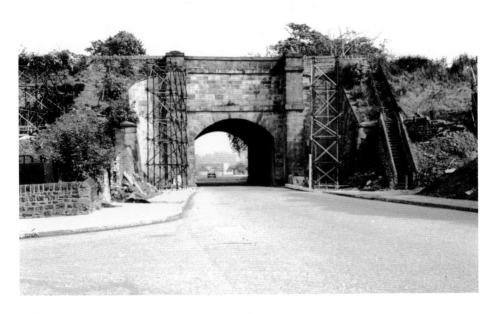

Bulk Road Aqueduct, Lancaster, Lancaster Canal

Bulk Road Aqueduct was placed south of the Lune Aqueduct and crossed the turnpike by this substantial passage. Road widening, carried out from 1960, led to the removal of the original aqueduct and its replacement with a new structure. As the canal was open to pleasure craft, a novel arrangement was made to convey boats along a temporary trestle structure in the dry. This structure also carried the piped water supply. (*RCHS Weaver Collection 47202*)

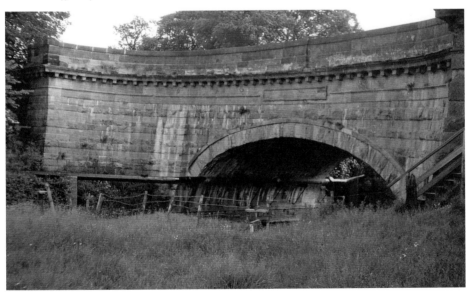

Garstang Aqueduct, Lancaster Canal

While the Lune Aqueduct is justifiably an impressive structure, the Lancaster Canal also has several other notable structures along its length. The aqueduct near Garstang crosses the River Wyre by a single arch. (*RCHS Slide Collection 58219*)

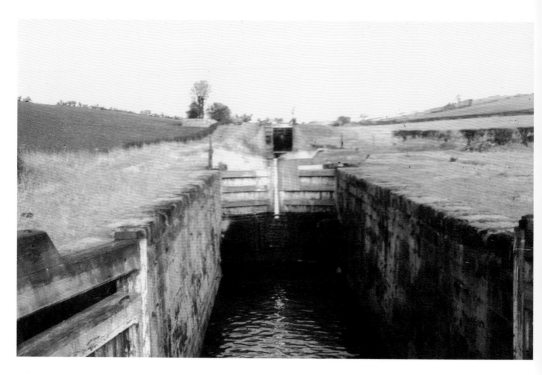

Lock 4 and 5, Tewitfield, Lancaster Canal, 1964
The Lancaster Canal was raised by eight locks at Tewitfield to the summit level that carried the waterway through to the terminus at Kendal. A reservoir was built at Killington, covering 153 acres, which supplied the canal. In the upper image, lock 4 is in the foreground, while the lower image shows the lock bridge and lock 5 chamber. These locks were completed during 1819. (*Above: RCHS Weaver Collection 47214. Below: RCHS Weaver Collection 47215*)

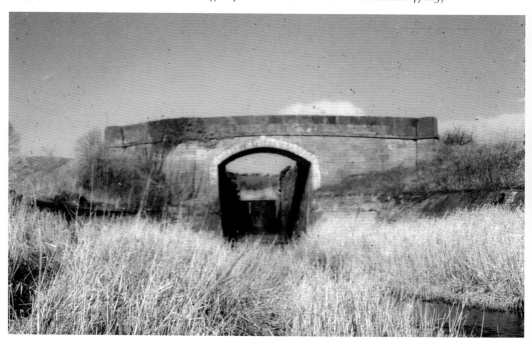

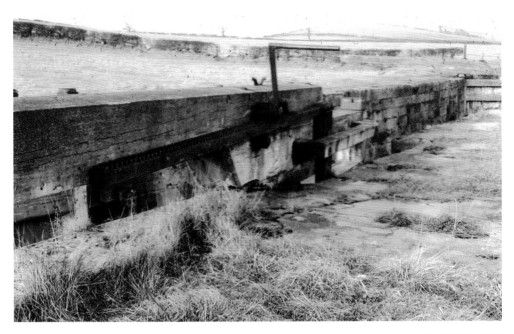

Above: Top Lock, Tewitfield,
Lancaster Canal, 1964
The gate paddles on the Lancaster
Canal lock had a rack and pinion
arrangement for opening and
closing the gate paddles. This type
of mechanism was also found on the
Glasson Dock Branch. (*RCHS Weaver
Collection 47218*)

Right: Hincaster Tunnel,
Lancaster Canal
The Lancaster Canal, north of
Tewitfield, which formed the
extension to Kendal, is now disused.
There was one tunnel at Hincaster
on this section, which was 378 yards
long. Hincaster was placed on the
part of the canal that turned west
before heading north again. (*RCHS
Slide Collection 58232*)

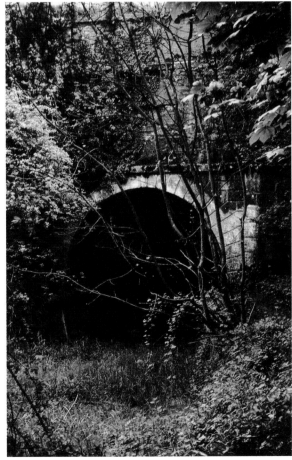

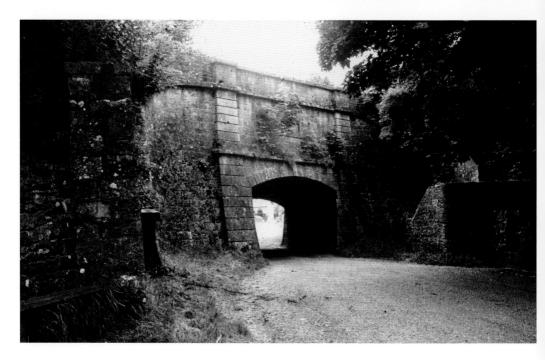

Sedgwick Aqueduct, Lancaster Canal
Sedgwick was one of six aqueducts built to span roads and streams (becks) on this northern extension. From here, the canal continued on to the terminus at Kendal. (*RCHS Slide Collection 58235*)

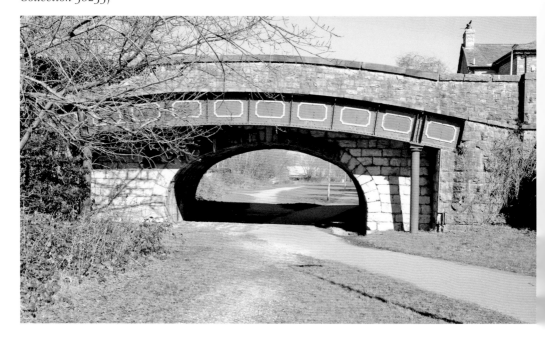

Kendal Castle Bridge, Kendal, Lancaster Canal
The last bridge before the basin at Kendal was widened and incorporated cast iron on both sides. (*Ray Shill 776931*)

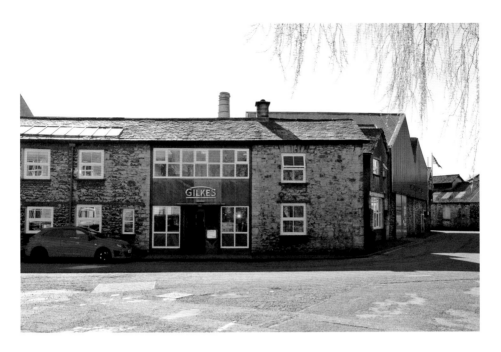

Canal Head, Kendal, Lancaster Canal

At the terminus of the Lancaster Canal was placed a warehouse (*above*). This structure remains and is incorporated into the Gilkes Foundry. This firm, which manufactures turbines, has been located on this site since 1858. It has therefore had a greater presence than the canal carrying department that was formerly located here. There is also an adjoining building that served as a ticket office (*below*). The foundry premises were extended onto the other parts of the basin, covering the former coal wharves. (*Above: Ray Shill 776951. Below: Ray Shill 776950*)

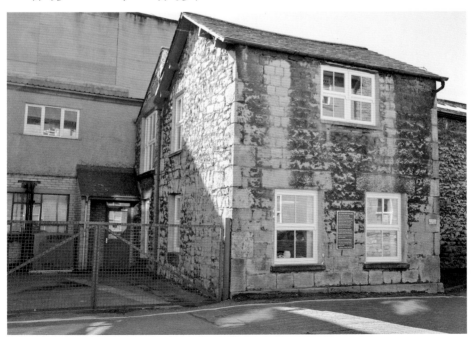

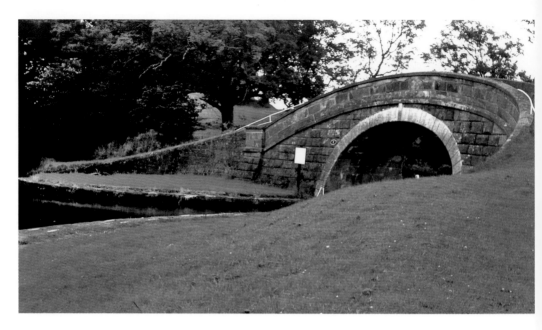

Glasson Dock Branch Junction, Towpath Bridge, Lancaster Canal
The Glasson Dock Branch was completed in 1825. It descended by six locks to the dock. The locks were 72 feet long by 14 feet 6 inches wide. These dimensions were the same as Tewitfield and were capable of passing the coastal vessels that travelled along the canal to Preston Basin. (*RCHS Slide Collection 58246*)

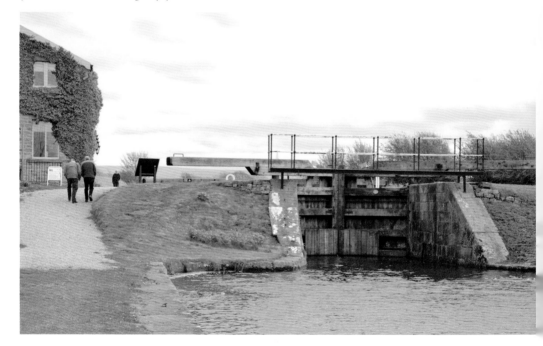

Lock 6, Glasson Branch, Lancaster Canal
Lock number 6 was the lowest of the locks that descended from the main canal at Galgate to Glasson Dock and the River Lune. (*Ray Shill 776285*)

Right: Lock 6, Former Mill, now Public House, Glasson Branch, Lancaster Canal
Water from the canal channel was used to drive the waterwheel for the mill. (*Ray Shill 776287*)

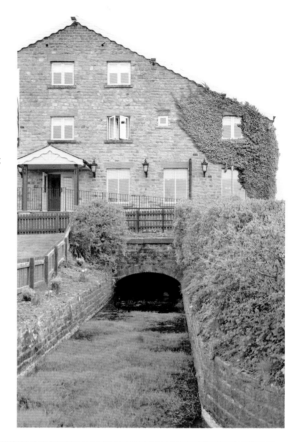

Below: Glasson Dock, Port of Lancaster
The tidal River Lune was a difficult navigation for craft. Shifting sands in the estuary was a handicap to navigation. Vessels docked alongside St George's Quay in Lancaster. With the completion of Glasson Dock in 1787, up to twenty-five vessels could be accommodated in this safe haven, which was 5 miles from Lancaster. (*RCHS Hugh Compton Collection 65131*)

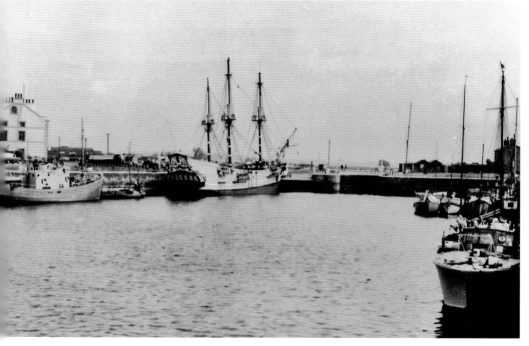

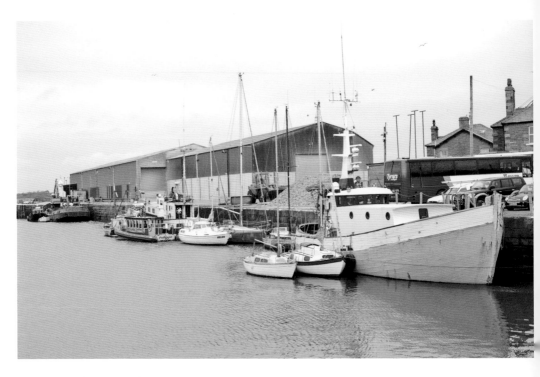

Glasson Dock, 2013 and 1980
The dock at Glasson is comprised of a large basin, with access to the River Lune through a 'sea lock' and another lock that gave entry to a larger, upper basin. From there the Glasson Branch (1825) leads to the main canal. (*Above: Ray Shill 776315. Below: RCHS Slide Collection 58256*)

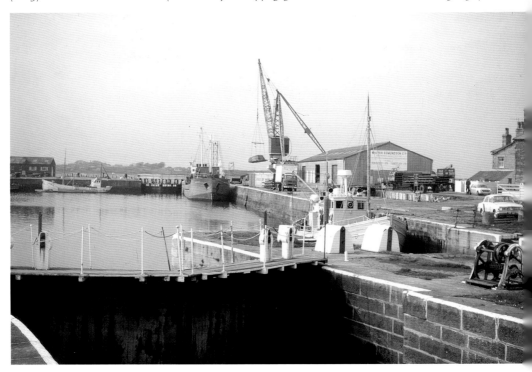

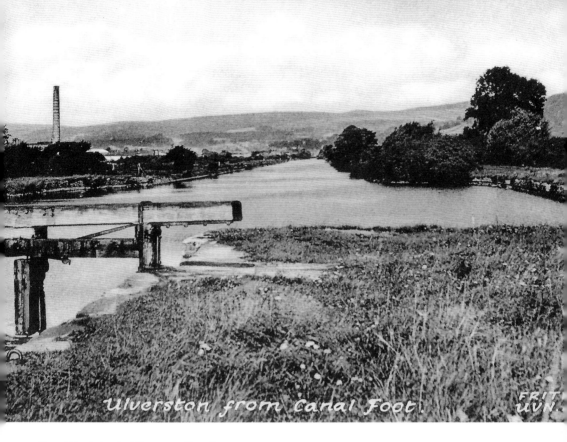

Canal Foot, Lock, Ulverston Canal
The Ulverston Canal was a straight canal, built for shipping to reach Ulverston. There was a single lock at Canal Foot. (*RCHS Postcard Collection 98201*)

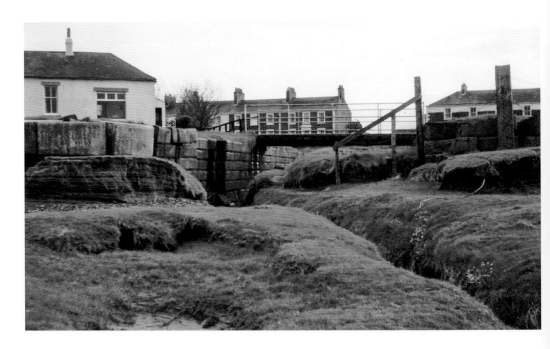

Sea Lock, Port Carlisle, Carlisle Canal

This lock enabled craft to access Solway Firth. From here, the route of the canal was 11¼ miles long to the terminus in Carlisle. There were eight locks on this navigation, each being 74 feet long by 17 feet 6 inches wide. Navigation of this waterway was relatively short. Traffic ceased in 1853, when the company decided to build a railway along the route (1854). Port Carlisle Basin was converted into an interchange point for rail transport and the canal company became the Port Carlisle Railway & Dock Company. (*Above: RCHS Transparency Collection 54871. Below: RCHS Transparency Collection 54873*)

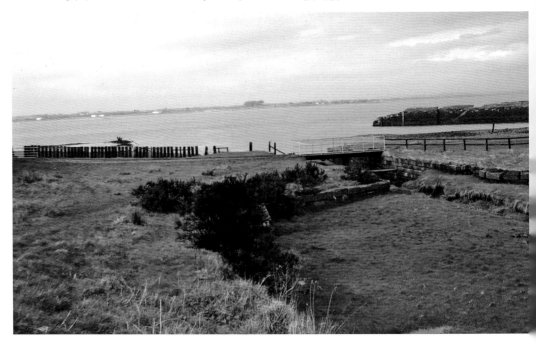

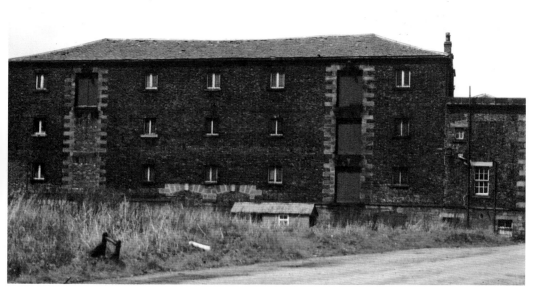

Warehouse, Carlisle Basin, Carlisle Canal

As a working waterway, the Carlisle Canal had a relatively brief existence. It was closed in 1853 and converted into a railway. The warehouses, however, remained. The central pair of entrance arches were bricked up, but retained a date stone of 1821. (*Above: RCHS Transparency Collection 54892. Below: RCHS Transparency Collection 54894*)

Chapter Two
Canals to Leeds

Bradford Canal, Leeds & Armley Navigation, Leeds & Liverpool Canal, Rain Hall Rock Canal and Springs Branch

The Leeds & Liverpool Canal crossed the Pennines after climbing from Burnley through seven locks at Barrowford, to the summit level near Foulridge. Here, it passed through Foulridge Tunnel (1,640 yards). Various feeders from reservoirs fed into the canal on either side of the summit section, providing the necessary supply to the canal. This water supply was improved over the years as trade increased. The last reservoir to be constructed in this part of the waterway was Winterburn, which was completed in 1891. A pipeline feeder to Greenberfield conveyed water from the reservoir into the canal.

The descent, from the summit to Leeds, was along a route that was among one of the earliest working sections of the canal. Construction began from the Leeds end and progressed towards Skipton. At Leeds, the canal joined the Aire & Calder Navigation.

From Foulridge to Greenberfield the canal is level, and near Barnoldswick is the site of the Rain Hall Rock Canal. This branch waterway was cut to extract limestone rock, which was moved by boat. This ½-mile-long waterway included two short tunnels.

A feature of the route to Leeds was the grouping together of locks as staircase locks. The frequent step increase in ground level led the engineers to choose this form. Here, a 2 rise lock and three 3 rise locks assisted the climb up the Aire Valley and across the hills to Bingley, Silsden and Skipton. At Bingley there were both a 3 rise and 5 rise. These are now the present limit of the groups of riser locks on the canal to and from Leeds. Another 2 rise near the summit, at Greenberfield, was replaced by two single locks.

At East Marton, the A59 crosses the canal by a distinctive double-arch bridge, before winding and turning through a series of sharp bends. It then makes another descent through a further six locks at Bank Newton. Then, the canal crosses the Aire for the first time at Priestholme Aqueduct. From here, the Aire Valley carries on to Leeds, passing first through Gargrave and another five-lock descent. This last section follows the River Aire, whose often turbulent waters proved a handicap to any proposals for extending the Aire & Calder Navigation beyond Leeds.

At Skipton, the private Springs Branch (Lord Thanet's Canal) joins the main waterway. On the Springs Branch were wharves where tramways brought limestone down to the waterside. From 1773, the first limestone was supplied from Lord Thanet's Quarries near Skipton Castle, while stone was sent for burning in kilns beside the Leeds & Liverpool and Bradford canals. The branch was extended by 240 yards in 1794, to create a new wharf built for railway trans-shipment from Haw Bank Quarries.

Between Skipton and Leeds, the canal passed through a busy industrial landscape, where the rivers once provided power for a number of mills. This was principally for the working of wools, although there were also various metalworking establishments including Kirkstall and Leeds forges. Here, the canal became useful for the movement of raw material and finished products.

Water supply came from a select number of rivers and streams, where permitted and the bult came from seven reservoirs. Apart from Rishton, all reservoirs were placed at or near the summit level: Foulridge Lower (1798), Slipper Hill (1832), Rishton (1832), Whitemoor (1840), Foulridge Upper (1866), Barrowford (1885) and Winterburn (1891).

Lock locations changed as the canal was made and improved. The final total was ninety-two: forty-five locks on the Leeds side and fifty-two on the Liverpool side. From Leeds to the tail of the twenty-first lock at Wigan, the lock dimensions were 14 feet 14 inches wide by 62 feet long.

Near Shipley, a junction was made with the independent Bradford Canal. This ascended through a series of ten locks to the town of Bradford, which opened in 1774. The owner was the Bradford Canal Company, and water for the canal was obtained from Bowling Mill Beck. While this supply was authorised by the Act of 1771, Bradford Beck was later dammed. An additional supply of water was diverted into the canal, although it had been prohibited by the Authorising Act of 1771. Heavy pollution from Bradford Beck and concerns for public health eventually led to the closure of the canal in 1867.

A new company was formed in 1871 to reopen the canal that had the original water source excluded. Five pumping engines, one at each group of locks, were constructed to pump water up the canal and eventually to the summit level. Restoration began in 1872, with the canal opening in two stages. First to Oliver Locks in 1872, and then on to reach Northwood Bridge Wharves in 1873. The remaining section from Northwood Bridge to Hoppy Wharf (⅜ mile) was closed and filled in. This new canal company lasted until 1878, when the waterway was purchased jointly by Leeds & Liverpool Canal Company and Aire & Calder Navigation. The canal was finally abandoned in 1922.

Features of this canal included: Windhill Lock & Pumphouse, Pricking Mill staircase (2 rise) & Pumphouse, Crag End staircase (3 rise), Oliver staircase (2 rise), Spink Well staircase (2 rise), Zetland Mills wharf (1873–1922) and Hoppy Bridge wharf (1774–1867).

A TABLE,

SHEWING THE DISTANCE OF THE SEVERAL TOWNS, BRIDGES, &c. UPON THE

LEEDS & LIVERPOOL CANAL,

AND

Douglas Navigation.

By T. Beeston, Leeds.

Place																																
Armley	2	Armley.																														
Kirkstall	4	2	Kirkstall.																													
Forge	5	3	1	Kirkstall Forge.																												
Rodley	7	5	4	3	Rodley.																											
Apperley	9	8	6	5	3	Apperley.																										
Junction	13	11	10	9	7	4	Junction.																									
Shipley	14	12	10	9	7	5	1	Shipley.																								
Dixon Mill	14	12	11	10	8	5	1	1	Dixon Mill.																							
Hirst Mill	15	13	11	10	8	6	2	2	1	Hirst Mill.																						
Bingley	17	15	13	12	10	8	3	3	2	2	Bingley.																					
Morton	18	16	15	14	11	9	5	5	4	4	2	Morton.																				
Stockbridge	20	18	16	15	13	11	7	7	6	5	4	2	Stockbridge.																			
Silsden	23	21	20	19	17	14	10	10	10	9	7	6	4	Silsden.																		
Kildwick	25	23	22	21	19	16	12	12	11	11	9	8	6	2	Kildwick.																	
Skipton	30	28	26	25	23	21	17	17	16	15	14	12	11	7	5	Skipton.																
Ingabridge	31	30	28	27	25	23	19	18	18	17	15	14	13	9	7	2	Ingabridge.															
Gargrave	35	33	31	31	28	26	22	22	21	21	19	17	16	12	10	6	4	Gargrave.														
Bank Newton	37	35	33	32	30	28	24	23	23	22	21	19	17	14	12	7	6	2	Bank Newton.													
Barnoldswick	42	40	39	38	36	33	29	28	28	28	26	25	23	19	18	13	11	8	6	Barnoldswick.												
Foulridge	46	44	42	41	39	37	33	32	33	31	30	28	26	23	21	16	15	11	10	4	Foulridge.											
Barrowford	48	46	44	44	41	39	35	35	34	34	32	30	29	25	23	19	17	14	12	6	3	Barrowford.										
Reedyford	49	47	46	45	43	40	36	36	35	35	33	31	30	26	25	20	18	15	13	7	4	2	Reedyford.									
Lomishaw	50	48	46	46	43	41	37	37	37	36	34	33	31	27	25	21	19	16	14	8	5	2	1	Lomishaw.								
Burnley	55	53	52	51	49	46	43	42	41	41	39	38	36	32	31	26	24	21	19	13	10	8	7	6	Burnley.							
Altham	61	59	58	57	55	52	48	48	47	47	45	44	42	38	37	32	30	27	25	19	16	14	12	12	6	Altham.						
Henfield	63	61	60	59	57	54	50	50	49	49	47	46	44	40	38	34	32	28	27	21	18	16	14	14	8	3	Henfield.					
Blackburn	71	69	67	67	65	62	58	57	55	55	53	52	48	46	42	40	36	35	29	26	24	22	22	16	10	8	Blackburn.					
Johnson's Hillock*	80	78	76	76	73	71	67	67	66	66	64	62	61	57	55	50	49	45	44	38	35	32	31	30	25	19	17	9	Johnson's Hillock.*			
Kirkless*	91	89	87	86	84	82	78	78	77	76	75	73	71	68	66	61	60	56	55	49	46	43	42	41	36	30	28	20	11	Kirkless.*		
Wigan	93	91	89	89	86	84	80	80	79	79	77	75	74	70	68	64	62	59	57	51	48	45	44	43	38	32	30	22	14	3	Wigan.	
Liverpool	128	127	125	124	122	120	116	115	115	114	112	111	109	106	104	99	98	94	92	87	83	81	80	79	74	68	66	58	49	38	36	Liverpool.

* *Kirkless is the East Junction, and Johnson's Hillock the West Junction of the Lancaster Canal.*

Leeds & Liverpool Canal Distance Table, 1817
This distance table was published in a Leeds Trade Directory. It principally singled out the important towns and wharves in Yorkshire, and across the Pennines into Lancashire. (*Heartland Press Collection 770099*)

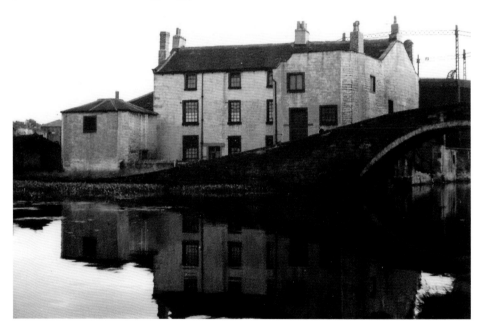

Shipley Junction, Leeds & Liverpool Canal/Bradford Canal, 1955
The Bradford Canal turned left at this point and the turnover bridge enabled boat horses to cross onto the Bradford Canal towpath. (*RCHS Hugh Compton Collection, G. J. Biddle 64254*)

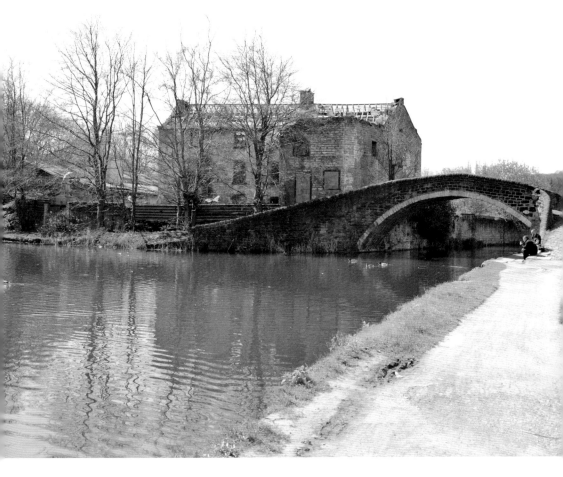

Bradford Canal Junction, 2014
Nearly sixty years on from the previous image, some features still remain. (*Ray Shill 769781*)

Spinkwell Engine House, Bradford Canal and Locks, 1955

Spinkwell was the last engine house to be constructed alongside the Bradford Canal. As this image shows, the waterway lay behind the engine house. The tall white building to the right was a canal cottage. The engine here, as with the other lock engines, was of the centrifugal type supplied by Gwynne of London. It was a combined engine and boiler manufactured by T. Green of Leeds. (*Above: RCHS Hugh Compton Collection, G. J. Biddle 64247. Below: RCHS Hugh Compton Collection, G. J. Biddle 64249*)

Windhill Lock, Bradford Canal (*Above*) and Oliver Staircase (*Below*), 1955
(*Above: RCHS Hugh Compton Collection, G. J. Biddle 64255. Below: RCHS Hugh Compton Collection, G. J. Biddle 64251*)

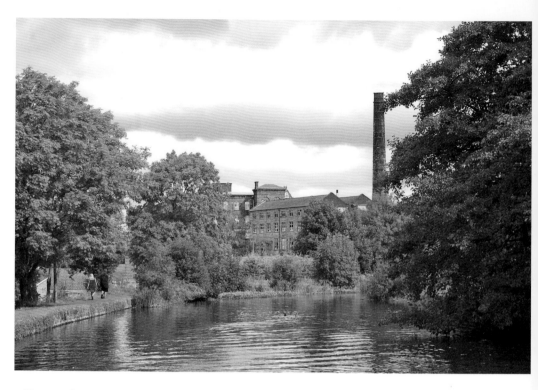

Mills at Nelson, Leeds & Liverpool Canal, 2009
The Leeds & Liverpool Canal turned north from Burnley towards Nelson, passing various mills that were engaged in the cotton trade. (*Above: Ray Shill 769053. Below: Ray Shill 769057*)

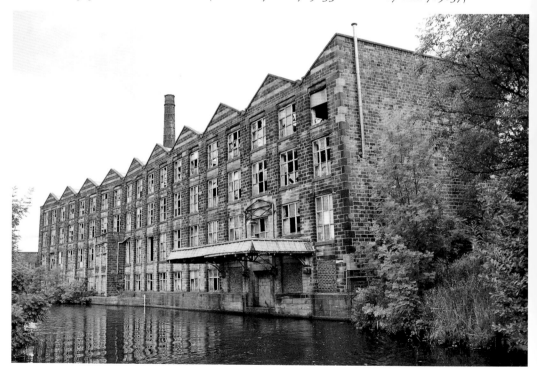

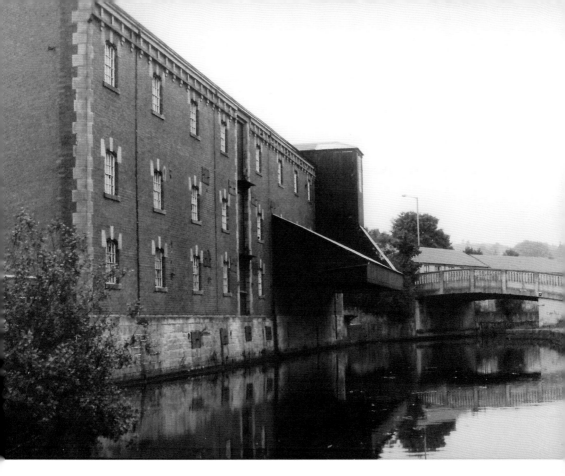

Company Wharf and Buildings, Carr Lane, Nelson, Leeds & Liverpool Canal, 1999
(*Ray Shill 769061*)

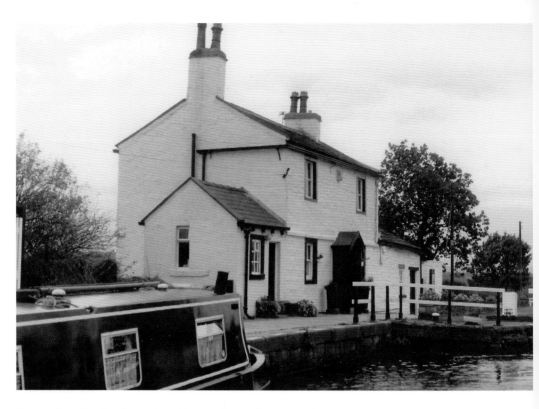

Barrowford Top Lock, Leeds & Liverpool Canal, 1999 and 2009
The last series of locks before the summit were at Barrowford. Here, the canal climbed out of the river valley and up towards Foulridge. (*Above: Ray Shill 769091. Below: Ray Shill 769088*)

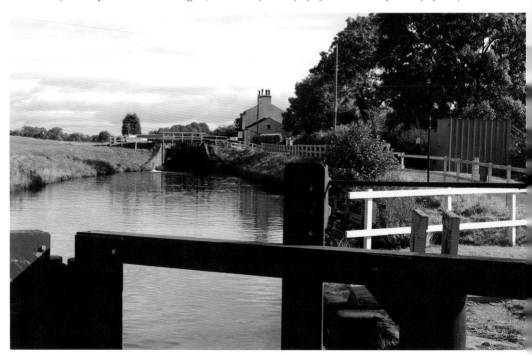

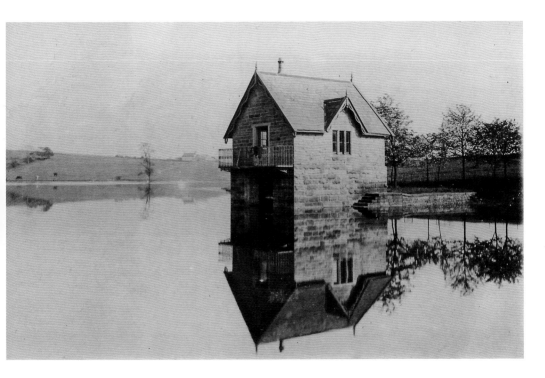

Upper Foulridge Reservoir, Leeds & Liverpool Canal
This reservoir was completed in 1866, supplementing the supply to the canal via the lower reservoir, which opened in 1798. In this view, the boat house and pier is seen in the foreground. (*RCHS Postcard Collection 96493*)

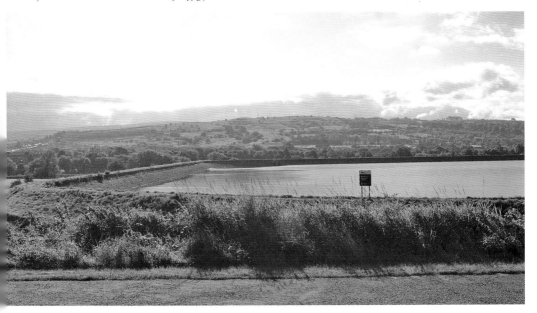

Barrowford Reservoir, Leeds & Liverpool Canal
This was completed during 1885 to improve water supply to the Lancashire side of the canal. The embankment was raised in 1896 to increase capacity. (*Ray Shill 769096*)

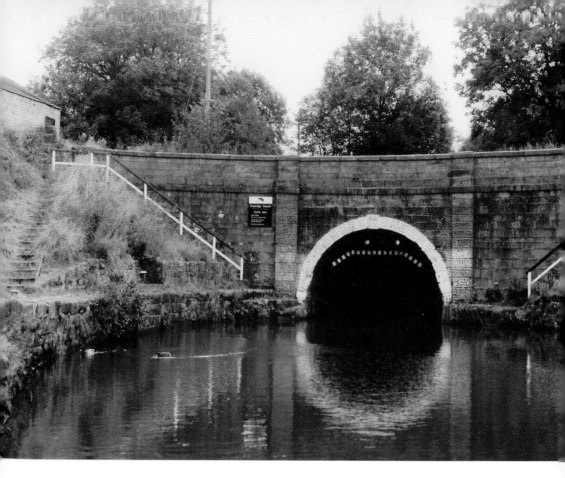

West Portal, Foulridge Tunnel, Leeds & Liverpool Canal

Foulridge Tunnel, which is 1,640 yards long, was constructed during the period Robert Whitworth was employed as engineer. During construction of this tunnel, mud and sand were discovered and an engine was erected to pump away surplus water. Because of the unstable surface, around 740 yards of the tunnel were made with the 'cut and cover' method. Here, the earth was dug out to canal level, the tunnel walls, invert and roof made, and then the ground above restored to the normal level. This was done by filling up the cutting above with the excavated earth. The rest was made through rock by the traditional means of sinking shafts. Construction took some four and a half years, with a final opening to traffic on 1 May 1796. The canal from Greenberfield had reached Foulridge by August 1794. (*Ray Shill 769105*)

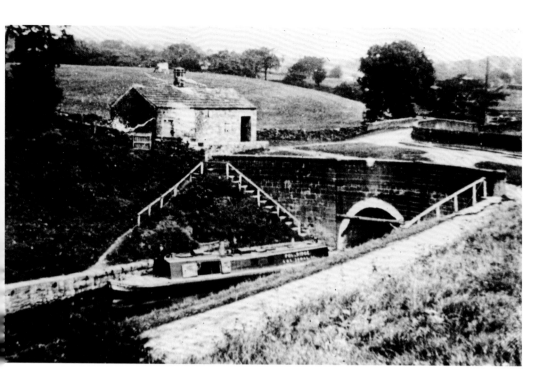

Foulridge Tunnel West (*Above*) and East Portals (*Below*), Leeds & Liverpool Canal
The traditional method of taking barges through Foulridge was by legging. Boat crews 'used their legs to push their craft through'. From 1880 (until the mid-1930s), a steam tug was provided. This tug was double ended, with a propeller and rudder at each end. (*Above: RCHS Weaver Collection 44197. Below: RCHS Slide Collection 58415*)

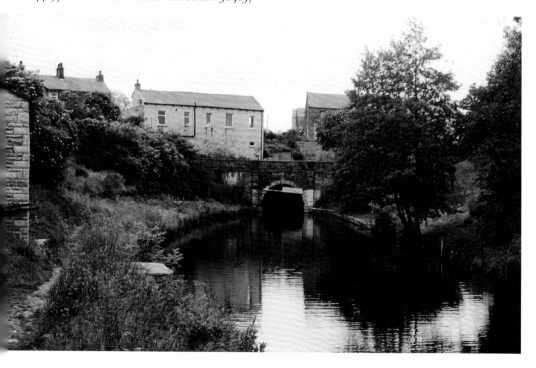

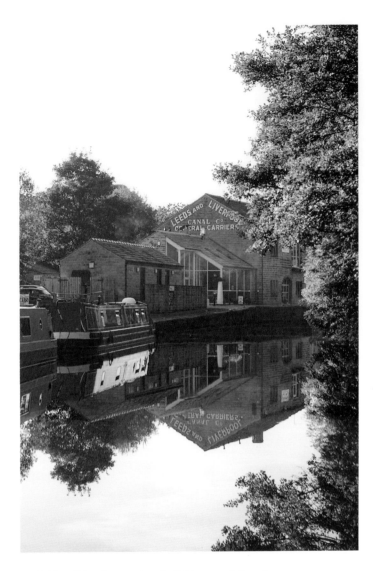

Foulridge Warehouse, Leeds & Liverpool Canal

The sign on the warehouse is a reminder of the time when the Leeds & Liverpool Canal Company were carriers as well as canal proprietors. During 1921, they decided to lease their boats to three major carriers: Lancashire Canal Transport of Blackburn, Benjamin C. Walls Ltd of Skipton and John Hunt and Sons of Leeds, who came together to form Canal Transport Ltd in 1930. (*Ray Shill 769121*)

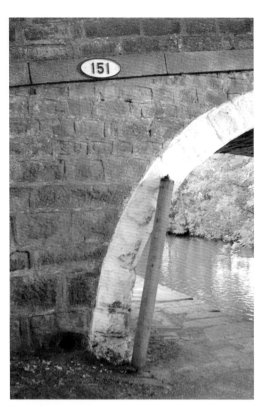

Tow Line Rollers, Salterforth, Bridge 151,
Leeds & Liverpool Canal
(*Right: Ray Shill 769175. Below: Ray
Shill 769176*)

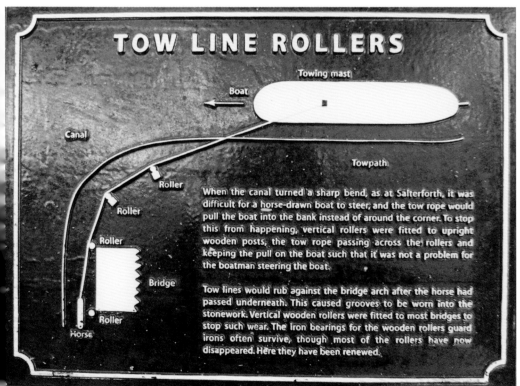

TOW LINE ROLLERS

Towing mast

Boat

Canal

Roller

Roller

Roller

Bridge

Towpath

When the canal turned a sharp bend, as at Salterforth, it was difficult for a horse-drawn boat to steer, and the tow rope would pull the boat into the bank instead of around the corner. To stop this from happening, vertical rollers were fitted to upright wooden posts, the tow rope passing across the rollers and keeping the pull on the boat such that it was not a problem for the boatman steering the boat.

Tow lines would rub against the bridge arch after the horse had passed underneath. This caused grooves to be worn into the stonework. Vertical wooden rollers were fitted to most bridges to stop such wear. The iron bearings for the wooden rollers guard irons often survive, though most of the rollers have now disappeared. Here they have been renewed.

Horse

Roller

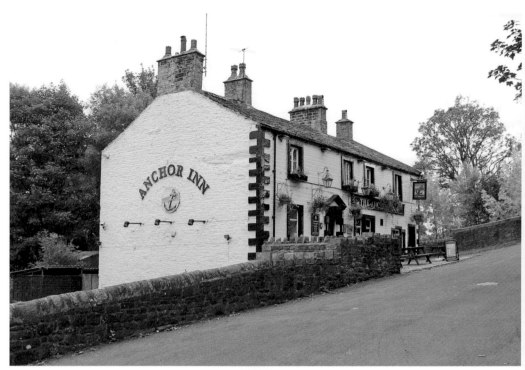

Anchor Inn, Salterforth, Bridge 151, Leeds & Liverpool Canal
The Anchor Inn at Salterforth has access from the road that was raised to pass over the canal at Bridge 151. The entrance is now at the original first-floor level, Initially, access came from a lower level. (*Above: Ray Shill 769171. Left: Ray Shill 769172*)

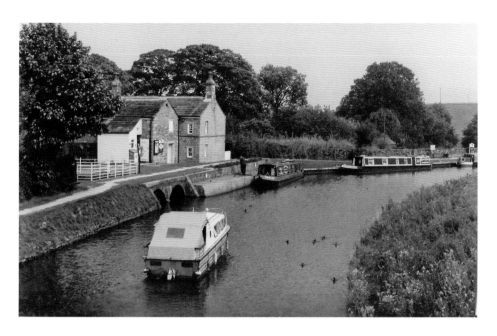

Greenberfield Top Lock, Leeds & Liverpool Canal
Greenberfield Top Lock was the entry point for the 9-mile pipeline from Winterburn Reservoir. This reservoir was placed on the upper part of Eshton Beck. It was completed in 1891, a little previous to the Act authorising its construction. The pipeline to Greenberfield was not finished until 1893. (*Ray Shill 769260*)

Greenberfield Original Lock Course, Leeds & Liverpool Canal
The double lock at Greenberfield was removed following a committee recommendation in 1817. John Rennie had been critical of the excessive loss of water here and recommended a replacement of two single locks. (*Ray Shill 769275*)

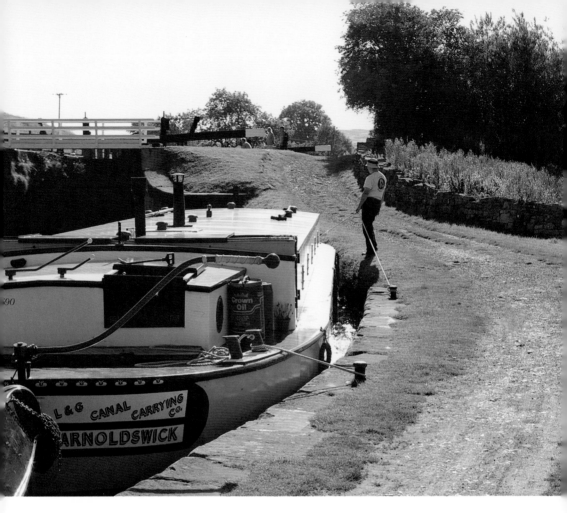

Greenberfield Lock 43, Leeds & Liverpool Canal
Some Leeds & Liverpool working boats have survived in private ownership. In this image, Barnoldswick awaits its turn for lock 43. Before lock 43 was reconstructed, the canal originally carried on in a straight line towards the locks. (*Ray Shill 769276*)

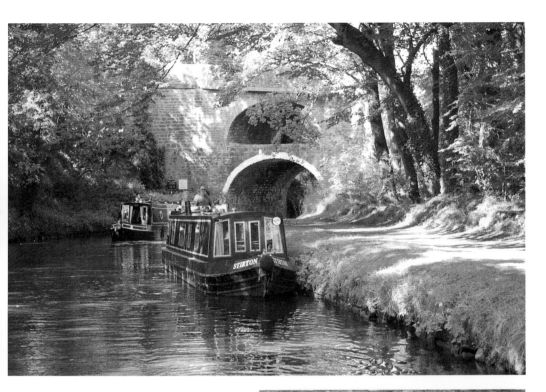

Bridge 161, East Marton, Leeds & Liverpool Canal

The road crossing at East Marton is known as the Double Arches Bridge, and supports the main road over the canal there. (*Above: Ray Shill 769302. Right: Ray Shill 769301*)

Leeds & Liverpool Canal, Near Newton Grange
East of the Double Arch Bridge, the canal turns back in a series of three sharp bends across wild and boggy terrain. (*Ray Shill 769310*)

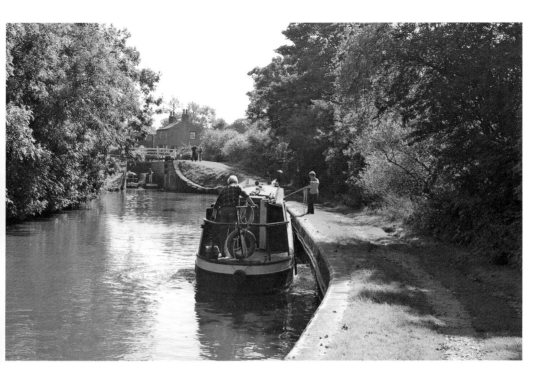

Bank Newton Locks, Leeds & Liverpool Canal

At Bank Newton, the canal descends towards the Aire Valley through five locks. Below the lowest lock (36) is a canal cottage with the inscription 'L & LC 1797'. This was the year that this section of canal was opened to Foulridge. (*Above: Ray Shill 769345. Below: Ray Shill 769352*)

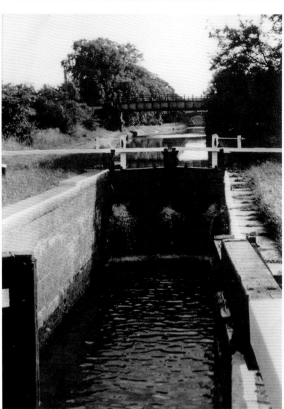

Above: **Priest Holme Aqueduct, Leeds & Liverpool Canal**

The Leeds & Liverpool Canal crossed the upper reaches of the River Aire at Priest Holme. The section from Gargrave to Foulridge was constructed during the canal mania period of the 1790s, and extends westward from Gargrave. Contracts were let in 1791 for Foulridge Tunnel and the locks at Gargrave, Bank Newton and Barrowford. (*RCHS K. Gardiner Collection 67214*)

Left: **Stegneck Lock and Midland Railway Bridge**

Stegneck was the highest of the group of locks at Gargrave. It was also near to where the Midland Railway main line crossed the canal. (*RCHS K. Gardiner Collection 67205*)

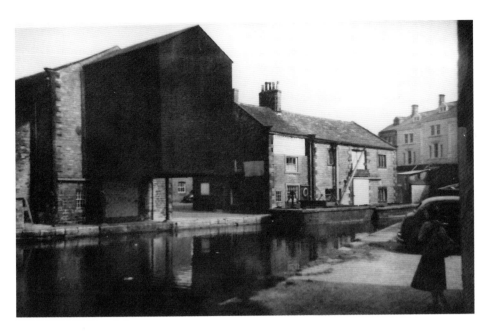

Skipton Warehouse, Leeds & Liverpool Canal

Merchandise trade on the Leeds & Liverpool Canal was often handled at a select group of warehouses along the waterway. While there were independent carriers that traded along the canal, the Leeds & Liverpool Canal Company also came to be canal carrier, operating fly boats and warehouses along the canal. These included establishments at Gargrave, Skipton, Silsden, Stocksbridge, Bingley, Shipley, Armley and Leeds. (*RCHS Hugh Compton Collection 65004*)

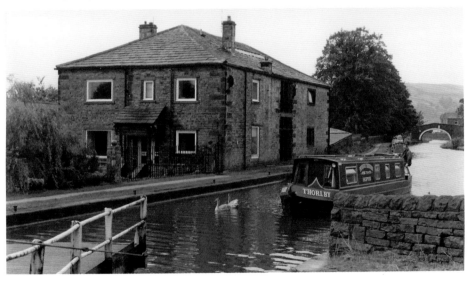

Kildwick, Swing Bridge 187 and Former Warehouse, Leeds & Liverpool Canal

Canal carriers also called at a number of smaller warehouse establishments, which included Barrowford, Salterforth, Barnoldswick, Kildwick, Morton, Shipley, Apperley, Rodley and Kirkstall. An important trade for all warehouses was the transport of wool. (*Ray Shill 769556*)

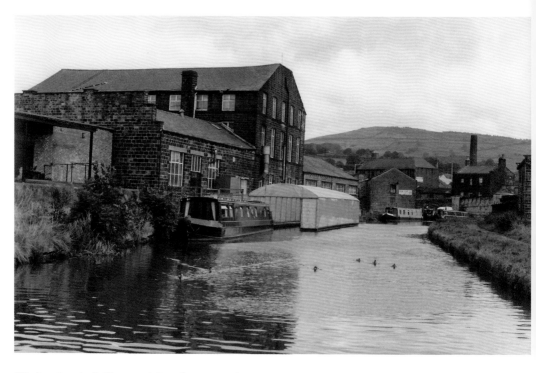

Silsden, Leeds & Liverpool Canal, 1999 and 1972
Silsden had a warehouse (*below*) that was used for interchanging road traffic on the route that linked Ilkley with Keighley. (*Above: Ray Shill 769571. Below: RCHS K. Gardiner Collection 67207*)

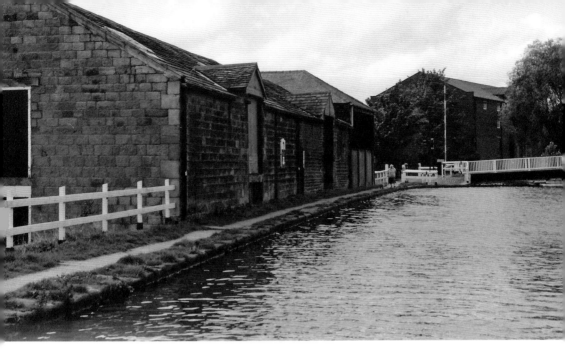

Stocksbridge Warehouses, Leeds & Liverpool Canal

Riddlesden or Stocksbridge Warehouses were placed near Keighley. The warehouse swing bridge crossed the waterway, and there was at one time an overhead travelling crane that also spanned the canal. The group of warehouses at Stocksbridge Wharf comprised buildings of different dates; those nearer the swing bridge were older than the larger warehouse (*see below*). (*Above: Ray Shill 769571. Below: Ray Shill 769631*)

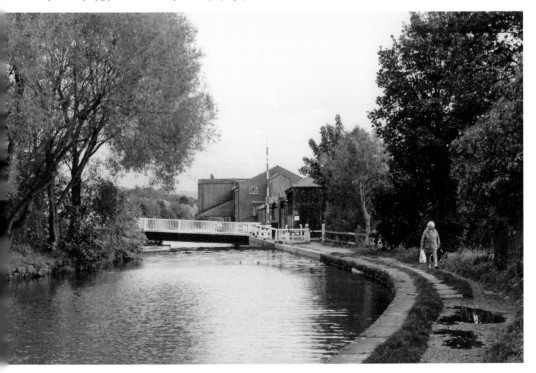

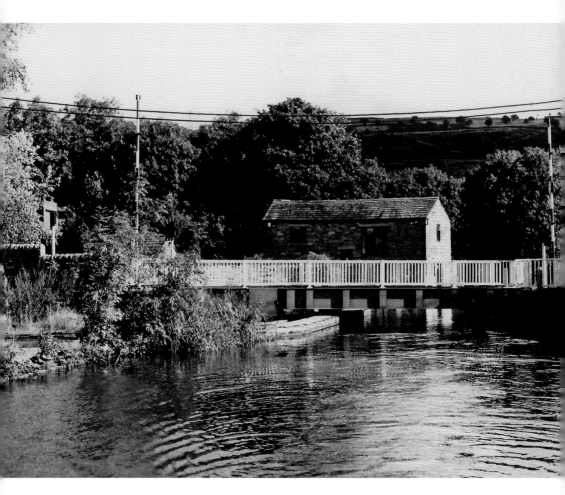

Morton Swing Bridge, Leeds & Liverpool Canal
Morton swing bridge carries Morton Lane over the canal. East of this bridge was located a wharf and warehouse and there was also an aqueduct further east that spanned the Morton Beck. (*Ray Shill 769645*)

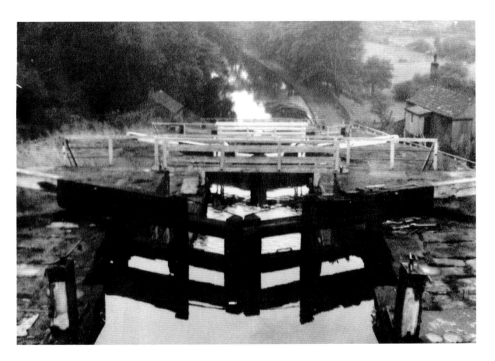

Bingley 5 Rise, Leeds & Liverpool Canal, 1962 and 1999
From Bingley to Leeds, the locks are often grouped as risers, or staircases, of 2 and 3. At Bingley, there is also a group of five together. The 5 rise is the steepest flight of locks in the UK, which a gradient of about 1:5 – a rise of 59 feet 2 inches (18.03 m) over a distance of 320 feet (98 metres). The intermediate and bottom gates are the tallest in the country. The view looking down the locks has changed with time, including the loss of the towpath buildings below the locks. The structure is Grade I listed. (*Above: RCHS K. Gardiner Collection 67240. Below: Ray Shill 769666*)

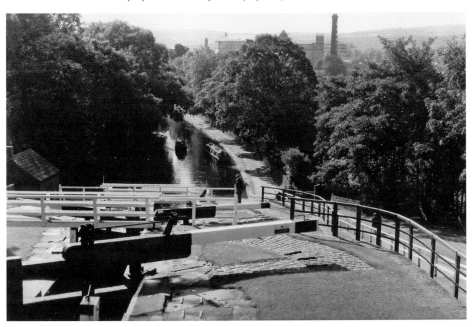

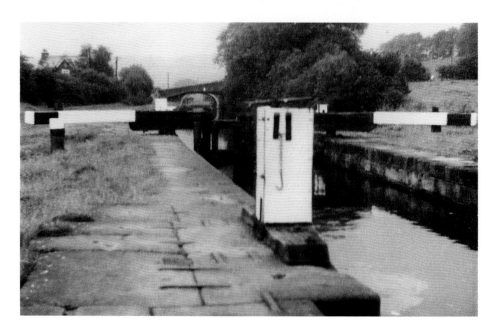

Dowley Gap 2 Rise, Leeds & Liverpool Canal, 1966
After Bingley 5 rise, the canal falls by another three locks at Bingley 3 rise and then continues on through Dowley Gap and under Scourer Bridge to Dowley Gap 2 rise. The distinctive ground paddles on these locks were, and still are, a common feature on this part of the canal. (*RCHS K. Gardiner Collection 67228*)

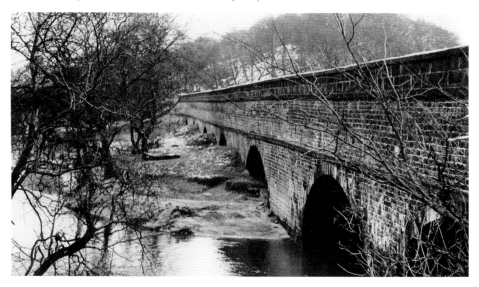

Dowley Gap Aqueduct, Leeds & Liverpool Canal
The canal from Skipton to Leeds was built for the Yorkshire committee, initially with James Brindley as engineer and Longbotham as clerk of works. Brindley resigned as engineer, owing to his other commitments, and Longbotham took over both roles. The first section to open was from Bingley to Skipton in April 1773, and from Bingley to Thackley later that year. This route included the crossing over the Aire by a seven-arch aqueduct near Dowley Gap. (*RCHS K. Gardiner Collection 67216*)

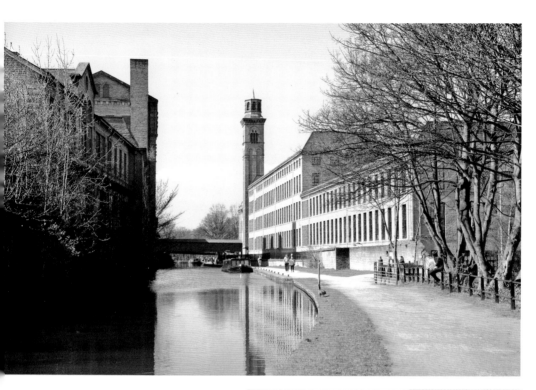

**Above: Saltaire,
Leeds & Liverpool Canal**
Titus Salt, who established a mill town
near Shipley, built the classic-style
buildings that still form an elegant
frontage for the canal. The mills
processed alpaca wool for the clothing
industry. (*Ray Shill 769732*)

**Right: Shipley Warehouses, Leeds
& Liverpool Canal, 1999**
(*Ray Shill 769757*)

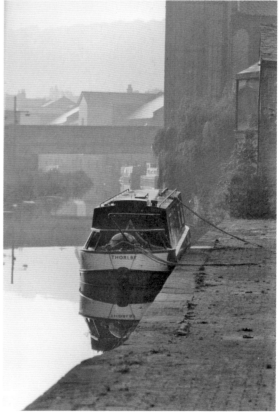

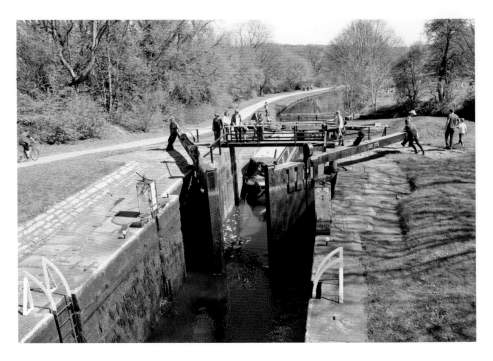

Newlay Locks, Leeds & Liverpool Canal, 2014
The triple staircase at Newlay is just as busy today as it was in times of commerce, with boaters regularly passing by. With the towpath a popular walk and cycle path, it may indeed be busier now than in the past. (*Ray Shill 769338*)

Kirkstall Brewery, Kirkstall, Leeds, Leeds & Liverpool Canal
At Bridge 222, the road climbs past the former Kirkstall Brewery. This has now been converted into accommodation for Leeds Metropolitan University. (*Ray Shill 770002*)

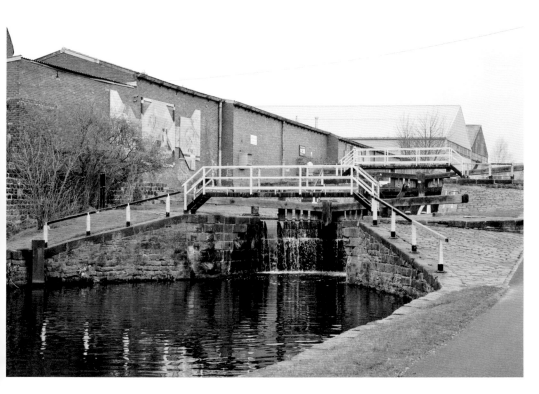

Oddy 2-Rise, Locks 4 and 5, Leeds & Liverpool Canal
In building the canal from Leeds, the engineer, Longbotham, chose to construct a number of staircase locks. The first staircase out of Leeds was named Oddy. Here, two locks raised the canal 13 feet 7 inches. The next group of locks were placed near Kirkstall Forge where there are two sets of 3-rise locks, Newlay and Forge. (*Ray Shill 770041 and Railway & Canal History Society, Michael Oxley Collection 85103*)

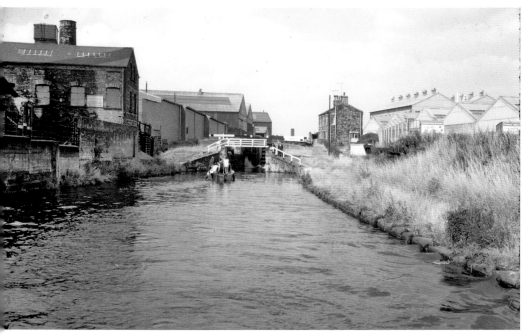

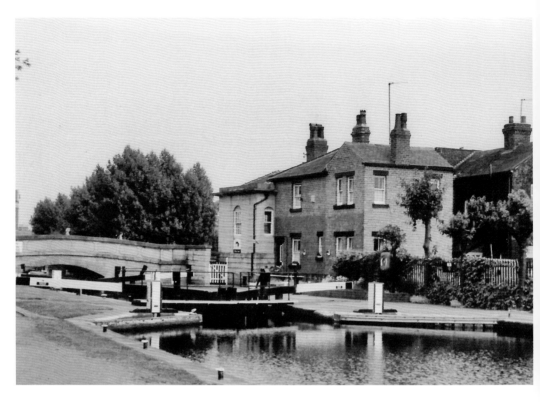

Office Lock No. 2, Leeds & Liverpool Canal
Office Lock is named as such due to the company offices there. East of this lock were warehouses,
wharves and boat building yards, now replaced by office, leisure and residential developments.
(*Ray Shill 77061 and Railway & Canal Society, Michael Oxley Collection 86108*)

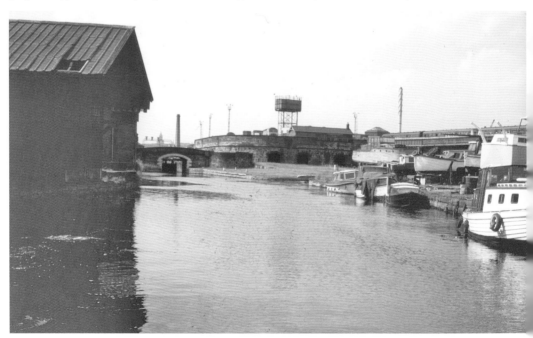

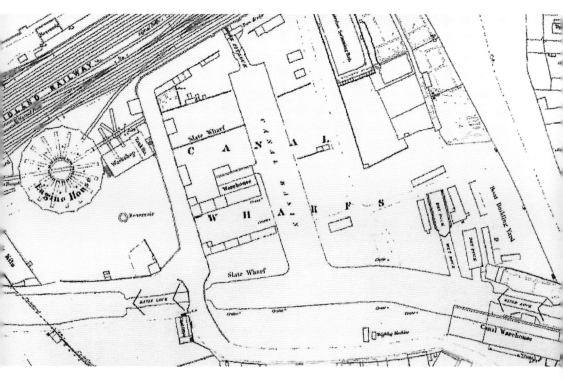

Leeds Canal Wharves, 1850

The Leeds & Liverpool Canal joined the River Aire at Leeds. Here, there was a large warehouse beside the river lock. The canal wharves were extended over time. From 1845, it had a second connection with the Aire above the weir, through the lock known as Arches (or Monk). This lock connection was made at the same time as the Leeds & Bradford Railway (opened July 1846) was constructed, on embankments and viaducts across the Aire Valley to Wellington Street station. Barges were then able to navigate the Aire towards Armley Mills. (*Heartland Press Collection 770100*)

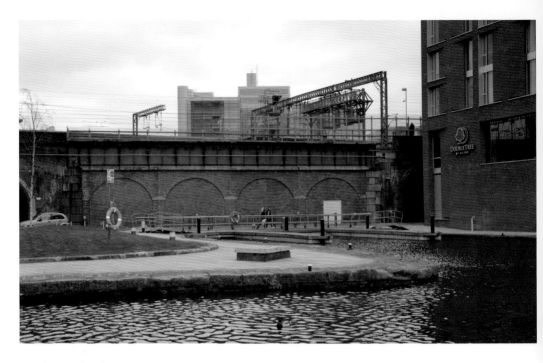

Armley Navigation, 2014
Though the lock chamber under the station is now sealed off, the silted up exit onto the Aire remains. It is visible from the opposite bank, especially during the winter months, when the vegetation has died. On the opposite side of the station, the entrance from the Leeds & Liverpool Canal is bricked up. (*Ray Shill 771061 and 771062*)

Right: Springs Branch, Skipton
The privately financed Springs Branch was
built for limestone transport. The limestone
was carried by boat to be burnt at the canalside
limekilns, alongside the Leeds & Liverpool and
Bradford canals. (*Ray Shill 770871*)

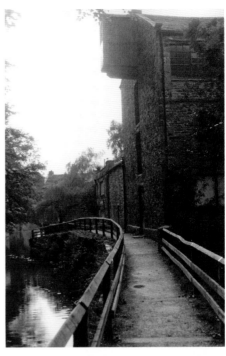

Below: Limestone Loading Shoots,
Springs Branch, Skipton
A tramway brought limestone down to the
Springs Branch for loading into boats. (*RCHS
Bertram Baxter Collection 21811*)

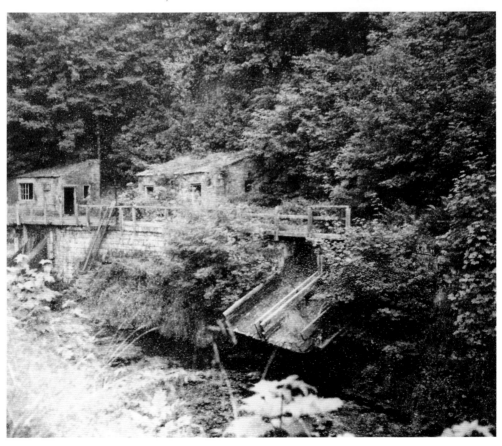

Chapter Three
Canals to Sowerby Bridge

The Rochdale Canal continued to climb from Manchester through Rochdale and Littleborough to the Summit Lock near Calderbrook. Here, the canal reached the 600 feet mark above the Ordnance Datum Level. It was a short summit for the canal then starts to descend again from Longlees Lock down to Walsden, Todmorden, Hebden Bridge and finally Sowerby Bridge, where the canal joined the Calder & Hebble Navigation.

Permission to build the Rochdale Canal was achieved in 1794, after a battle between two rival schemes. At the heart of this rivalry was the trade to Hull, which included textiles from that port. The Rochdale scheme, which proposed to link Manchester with Sowerby Bridge, gathered serious support during 1791. At the same time, a canal was promoted from Bury to Sladen, near Littleborough, which might have joined the Rochdale's planned line, but later also came to be extended to Sowerby Bridge.

Various schemes were proposed, including one by John Rennie, engineer. He suggested Hollingworth Reservoir and a summit tunnel. Another scheme by William Jessop proposed seven more locks each side and a cutting, also suggested Blackstone Edge Reservoir and a regulating reservoir at Chelburn, which could be the main supply in the winter. After two failed attempts to get the scheme authorised, William Crosley's survey from the Bridgewater Canal at Castlefield, through Littleborough and Hebden Bridge, was finally passed by Parliament on 4 April 1794.

The Rochdale Canal was completed, from Sowerby Bridge to Rochdale, by December 1798, and from Castlefield to Piccadilly during 1799. The intervening section's construction was delayed, chiefly through finance. On 21 December 1804, this canal was finally finished from Hopwood to Piccadilly and became the first trans-Pennine canal to be fully opened.

Fifty-six locks on the western side and thirty-six on the eastern side were made, which is a total of ninety-two to the junction with the Bridgewater at Castlefield. Their dimensions were made 14 feet and 2 inches wide by 74 feet long, which permitted a variety of boat traffic, including narrowboats, flats, keels and sloops.

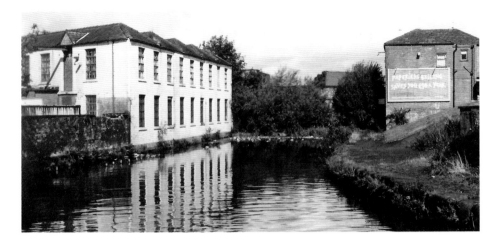

Rochdale Branch Junction, Rochdale Canal

Only a short section of the branch to Rochdale Basin remains. Opened in 1798, with the main route over the Pennines to Sowerby Bridge, this branch was ½ mile long and terminated in a pair of basins near to the town centre. In this image, the building on the left was a cotton mill. (*Ray Shill 834755*)

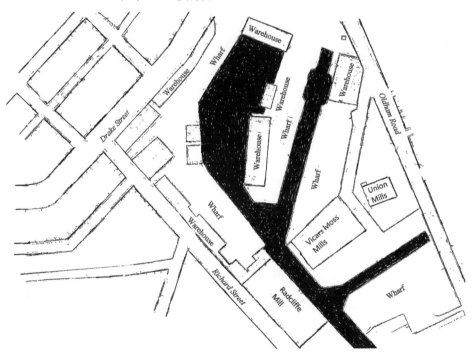

Rochdale Branch Basin, Rochdale Canal, 1850

This sketch map shows the shape of the basin at Rochdale, which was north of the railway and is now filled in. There were a number of warehouses and coal and timber wharves. In the period prior to the building of the railway through Rochdale, these wharves were host to a wide variety of craft, including narrow canal carriers on the network to London, the Potteries, the West Midlands and the East Midlands (Messrs Bache & Suttons). (*Ray Shill 834755*)

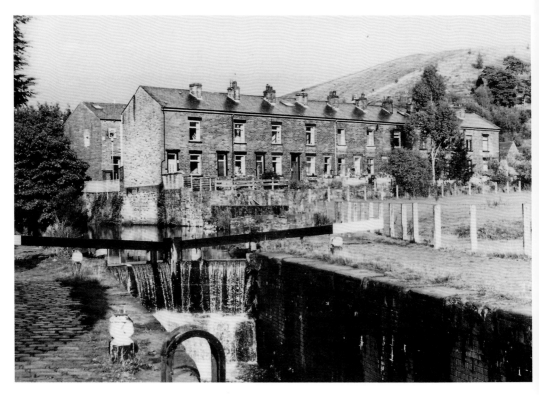

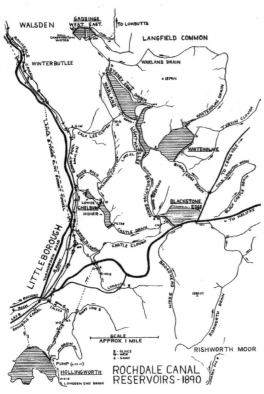

Above: **Littleborough Locks, Rochdale Canal**
There are twelve locks in the flight that descends 90 feet from the summit at 600 feet to Littleborough. (*Ray Shill 839421*)

Left: **Rochdale Canal Reservoirs**
Eight reservoirs provided the supply to the summit of the Rochdale Canal. These were: Blackstone Edge (1801), Gaddings (1835), Hollingworth (1800), Light Hazzles (1816), Lower Chelburn (1837), Snoddle Hill (Upper Chelburn, 1799), Warland (1857) and White Holme (1816), which were linked by various drains and channels. (*RCHS Collection*)

HOLLINGWORTH LAKE.

Hollingsworth Lake, Rochdale Canal
Hollingsworth Reservoir was completed in 1800, and came to be used as a compensation reservoir for traffic using the Manchester side of the canal. During 1923, an Act was obtained to authorise the sale of this reservoir to the Rochdale and Oldham Waterworks. (*RCHS Postcard Collection 97301*)

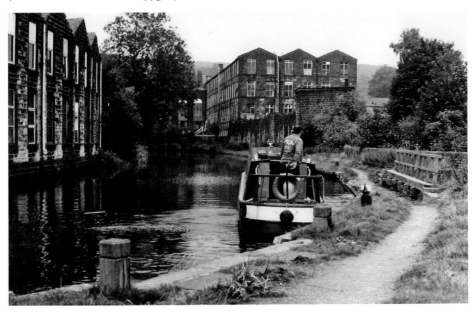

Walsden, Rochdale Canal
The canal at Walsden lock 27 is surrounded by mills that were engaged in weaving cotton. In this view, Alma Mill was placed on the left and Hollin's Mill is seen in the background on the right. (*Ray Shill 835603*)

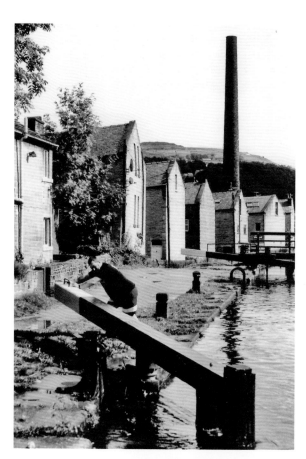

Left: **Stubbins Higher Lock, Rochdale Canal**
The descent to Hebden Bridge includes two locks at Stubblins Holme, known as the Higher and Lower locks where a group of terraced houses back onto the canal. Below this pair of locks was a cotton mill known as the Calder Mill. (*Ray Shill 836353*)

Below: **Canal Warehouse, Gauxholme, Rochdale Canal** (*Ray Shill 835811*)

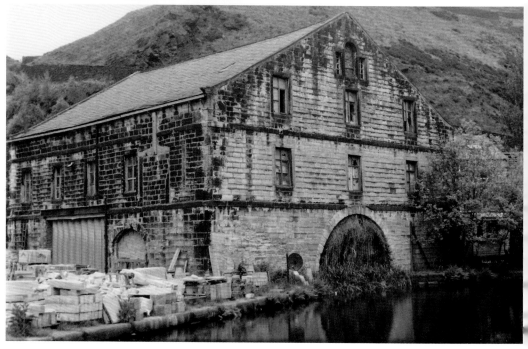

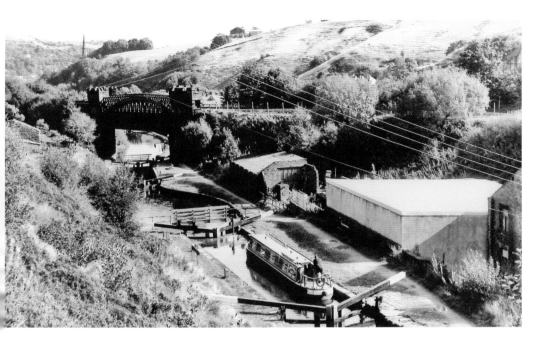

Gauxholme Viaduct and Lock 21, Rochdale Canal
There are four locks at Gauxholme which form part of the climb up to Todmorden. The canal is also spanned by the Manchester & Leeds Railway viaduct, which is constructed from stone. The engineer for this railway was George Stephenson and the viaduct is listed Grade 2. (*Ray Shill 835827*)

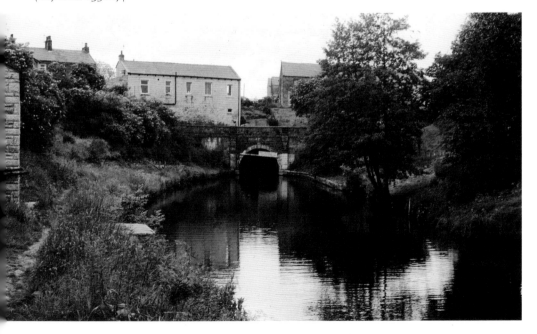

Warehouse, Todmorden, Rochdale Canal
A warehouse was placed beside the towpath in central Todmorden, opposite an enormous blue-brick retaining wall that supports the railway. (*RCHS Transparency Collection 59601*)

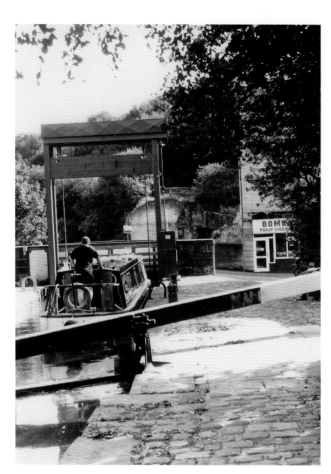

Left: Todmorden (or Library 19) Lock, Todmorden, Rochdale Canal
The provision of a guillotine, lower lock gate enabled restoration of the waterway without raising the road bridge. (*Ray Shill 835952*)

Below: Old Royd Lock, Near Todmorden, Rochdale Canal (*Ray Shill 836051*)

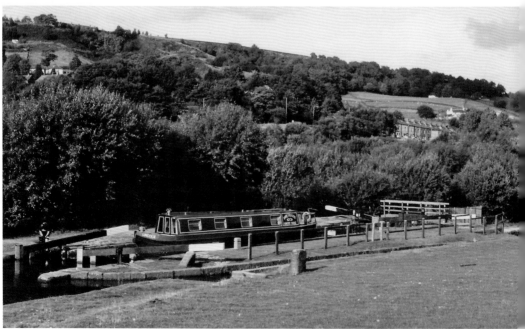

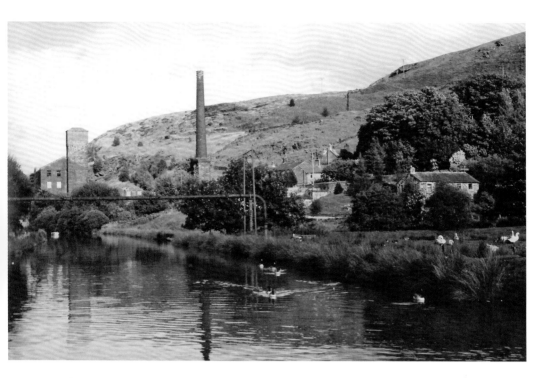

Woodhouse Mill, Near Todmorden, Rochdale Canal
(*Ray Shill 836062*)

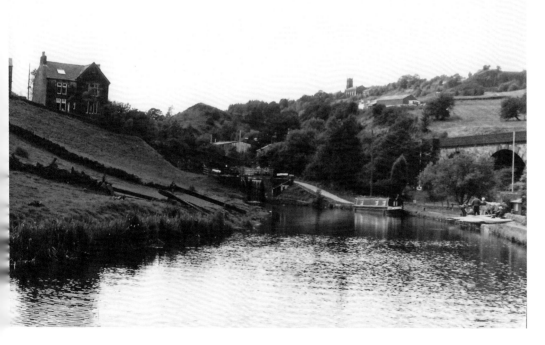

Lob Mill Lock and Railway Viaduct, Rochdale Canal
(*Ray Shill 836120*)

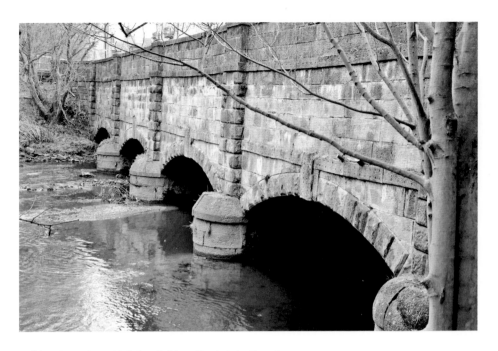

Calder Aqueduct, Hebden Bridge, Rochdale Canal, 2014
William Crosley Senior was responsible for much of the engineering at the Rochdale Canal. He had staked out the route, and with William Jessop, had inspected it. Crosley died in 1796, and was succeeded in the role of resident engineer by Thomas Bradley and Thomas Townshend. Bradley also died in 1797, and so any interpretation of whom was responsible for the design of this aqueduct is complicated. Even if Townshend supervised construction, it is reasonable to assume a share of the design credit must lie with either Crosley or Jessop. (*Ray Shill 836445 and 835446*)

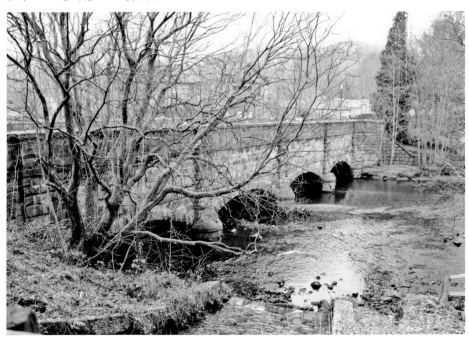

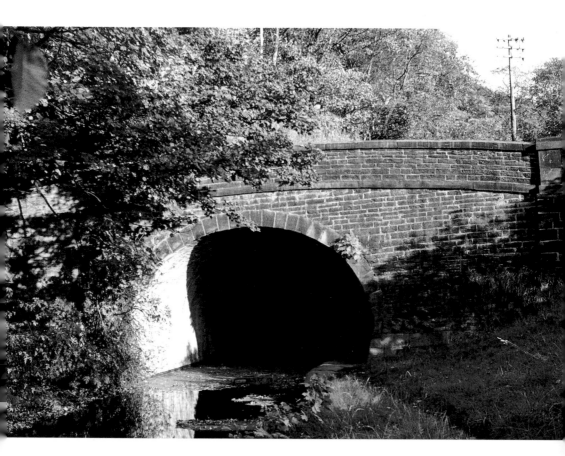

Sowerby Long Bridge, Rochdale Canal

The Rochdale Canal was built without tunnels, but at Bridge No. 2 the road crosses the canal obliquely and the canal was carried underneath through what must be considered a short tunnel. (*RCHS Transparency Collection 59630*)

Chapter Four
Canals to Huddersfield

The Huddersfield (Narrow) formed a junction with the Ashton Canal and climbed up to Diggle, where it passed through Standedge Tunnel to Marsden, before descending again to Huddersfield. Here, it met Sir John Ramsden's Canal, otherwise known as the Huddersfield (Broad) Canal, before another descent was required to take craft onto the Calder & Hebble Navigation at Cooper's Bridge.

Many of the northern waterways were built wide enough for barge traffic, and the two other Pennine crossings were barge canals. The shortest route, however, was destined to be a narrow canal. Those interested in the project included Benjamin Outram, who became engineer for the canal scheme in 1794 when the Huddersfield Canal Act was authorised. Nicholas Brown, who surveyed the route, was appointed surveyor and superintendent. Construction of the canal started from each end. At Huddersfield, a trans-shipment basin (Apsley) was required for trade from narrowboats to be exchanged with craft up to dimensions of 57 feet 6 inches by 14 feet 2 inches. Such craft were commonly known as Yorkshire Keels, although in later time those keels that came up to Huddersfield were also called 'West Country'. At Ashton, the junction is made with the Ashton. Here, it was also linked to the Peak Forest that climbed up to Marple, Bugsworth, and had links by plateway to the various lime quarries near Chapel-en-le-Frith.

The biggest challenge was the long tunnel at Standedge, which was initially 3 miles and 176 yards long. Contractors began work at both ends. Shafts were also sunk along the line to raise water and spoil from the workings.

Construction of the canal from Ashton to Uppermill, near Saddleworth, was achieved by August 1797, and Wool Road in early 1799. The Marsden to Huddersfield section was also finished, as was the important Ashton Canal link to the Rochdale Canal at Piccadilly in Manchester. The Rochdale Canal locks were long enough to admit narrowboats and through traffic to Castlefields Basin on the Bridgwater. Potential traffic by boat, from Manchester to Wooroad, was now possible. Nature took a hand in the form of serious flooding and part of the Huddersfield Canal was destroyed, which was by some accounts poorly executed. Most serious was the destruction of the aqueduct near Stalybridge across the Tame. Work went on to repair the damage during 1799 and 1800. Trade finally started the next year to Wool Road, with goods carried by road over the tunnel site.

Making Standedge Tunnel was a slow process. Work was limited by finance and two Acts were required for authorising additional capital. Further handicaps followed with the failure of the company bankers in September 1810, and the bursting of Diggle Reservoir in November 1810. Finally, the tunnel was finished in March 1811, with an official opening on 4 April. Standedge was the costliest canal tunnel in Britain. At 9 feet wide, with 9 feet headroom, it was also the longest.

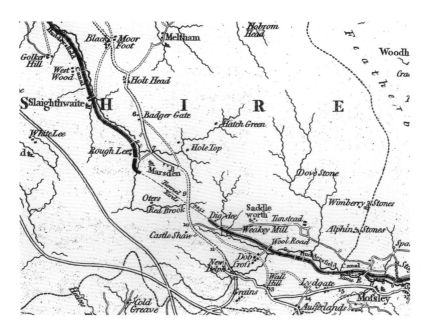

Huddersfield Canal Plan, 1795

Carey's map shows the route of the Huddersfield Canal as planned. Also shown is the route of the Huddersfield–Oldham Turnpike, which crossed over the top of the hills from Marsden to New Delph. While the tunnel was being constructed, temporary termini were made at Marsden and Wool Road, and the turnpike became the means of trans-shipping goods sent to and from Manchester or Huddersfield. Carey's map does not show the reservoirs as built, although the brooks that fed them, such as the Red Brook, are mentioned. (*Heartland Press Collection 237012*)

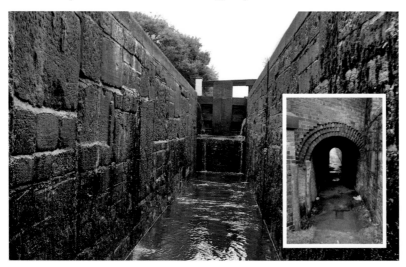

Towpath Tunnel and Lock 1 Chamber, Huddersfield Canal

The Ashton Canal joins the Huddersfield Canal, with craft passing out of Lock 1 of the Huddersfield onto the Ashton. Boat horses and boatmen used the adjacent pedestrian and horse tunnel to reach the lockside. (*Ray Shill*)

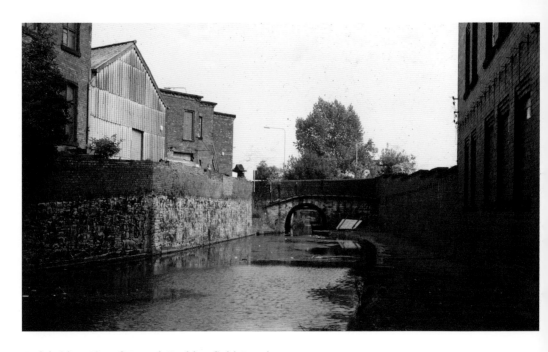

Stalybridge, Site of Tunnel, Huddersfield Canal
The Huddersfield Canal originally passed through a 198-yard tunnel, which was later opened out but still retained the channel width. (*RCHS Slide Collection 57661*)

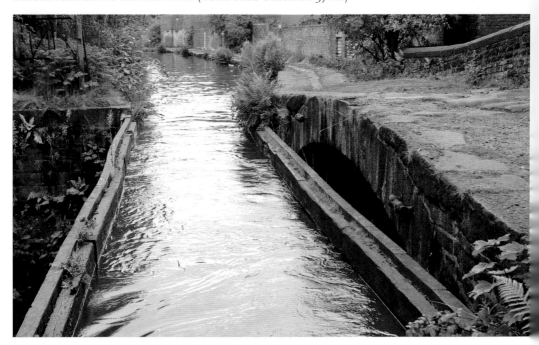

Tame Aqueduct, Stalybridge, Huddersfield Canal
The original stone aqueduct was damaged by a flood, and the trough was replaced with a cast iron structure under the direction of the engineer Benjamin Outram. The iron segments were supplied by the Butterley Ironworks. (*Ray Shill 772061*)

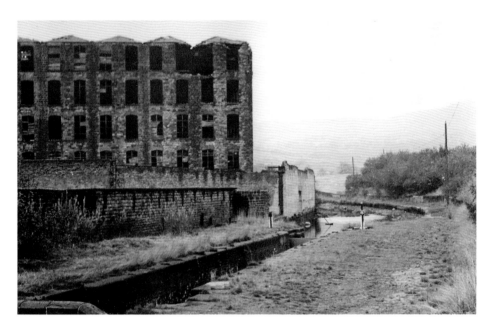

Mossley Mill, Lock and Former Gasworks Site, Huddersfield Canal
Stalybridge Gas Company made town gas at the Micklehurst Works beside the waterway. Cotton was woven at the Spring Mill seen in the background. (*RCHS K. Gardiner Collection 67156*)

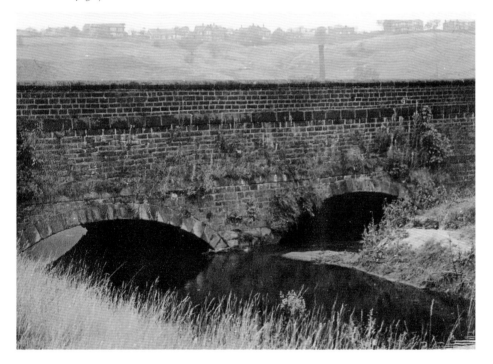

River Tame Viaduct, Huddersfield Canal
The canal crosses the Tame north of lock 18W. This structure is often referred to as the Royal George Aqueduct. (*RCHS K. Gardiner Collection 67158*)

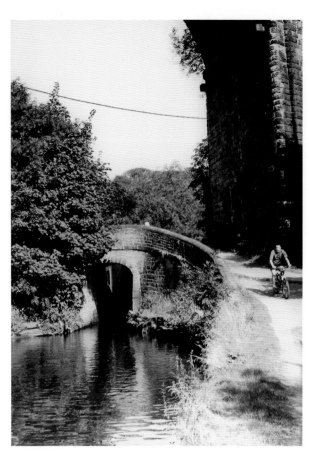

Left: Lock 23W, Upper Mill, Huddersfield Canal
There are thirty-two locks in the rise from Stalybridge to the summit at Diggle. (Ray Shill 773169)

Below: Lock 29W, Cast-Iron Lock, Huddersfield Canal
The climb to the summit passed various mills. In this image, the mill belonging to W. H. Shaw is seen. The distinctive style of inclined paddle gear is also worth noting. Locks on the final section to Diggle, once the canal was restored, were fitted with this arrangement. (*Ray Shill 773395*)

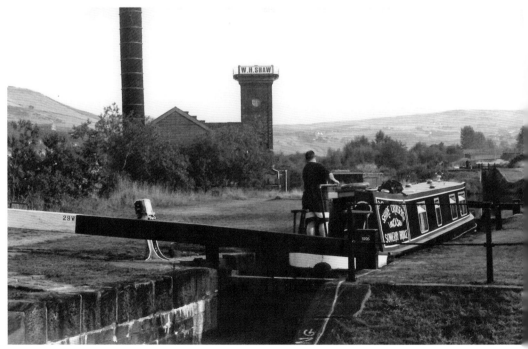

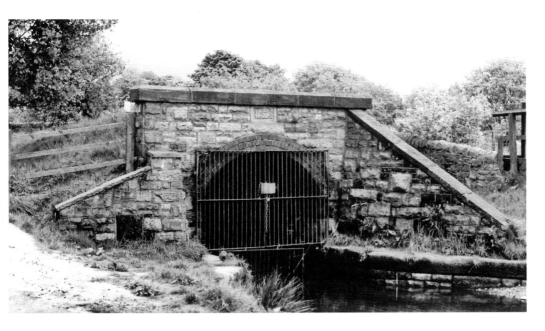

Diggle Portal, Standedge Tunnel, Huddersfield Canal
The Standedge Tunnel was extended at the Diggle end, and also under the railway tracks that passed through the adjacent railway tunnels. This increased the length of the tunnel to 5,686 yards. The alteration created a rather inconspicuous portal to Britain's longest canal tunnel. (*Ray Shill 773410*)

Marsden Top Lock 42E
The top lock at Marsden was, following abandonment, converted into a cascade for maintaining the water channel. (*Railway & Canal Historical Society, Michael Oxley Collection 86295*)

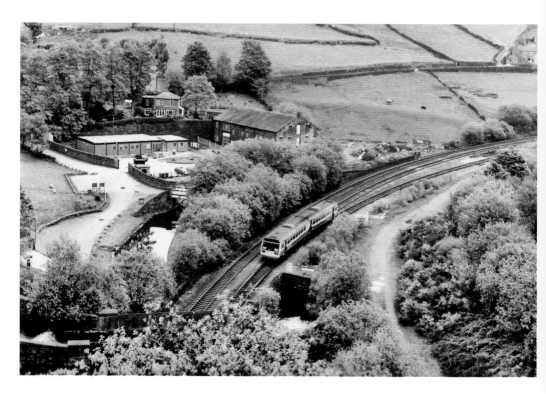

Marsden Portal, Standedge Tunnel and Railway, Huddersfield Canal
The Huddersfield Canal is seen to the left of the railway, together with the feeder (*bottom left*) that fed water from Tunnel End Reservoir into the canal. A view of the railway tunnels, canal tunnel and the feeder from Tunnel End Reservoir is seen below. The original railway tunnels are on the left with the LNWR tunnel (*centre*). (*Ray Shill 77461* and *RCHS K. Gardiner 67114*)

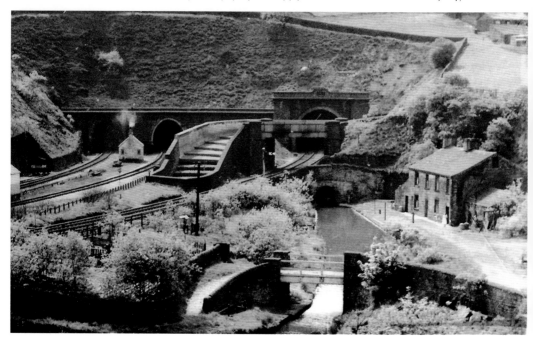

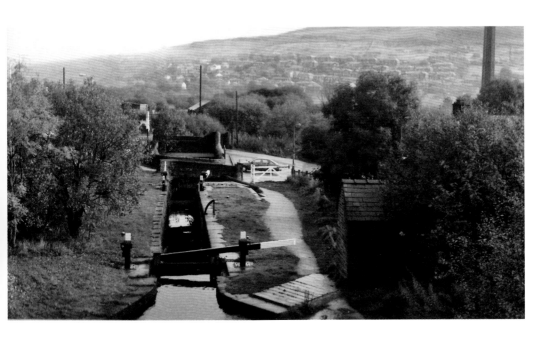

Marsden, Huddersfield Narrow Canal
The descent from Marsden to Huddlesfield follows the Colne Valley. At Marsden, the River Colne is formed at the meeting of streams such as the Haigh Clough and Redbrook, which also provide water for the canal reservoirs. (*Ray Shill 773661*)

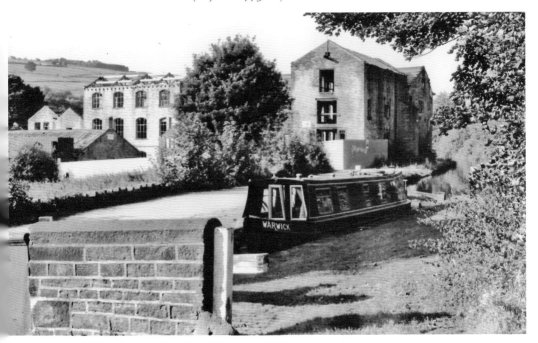

Lock 17E, Huddersfield Canal
The Mill at Low Westwood was a woollen mill whose mill pond was separated from the canal by the tow path. Lock 17E is placed east of this mill and Low Westwood (iron and brick) bridge spanned the tail of the lock. (*Ray Shill 774608*)

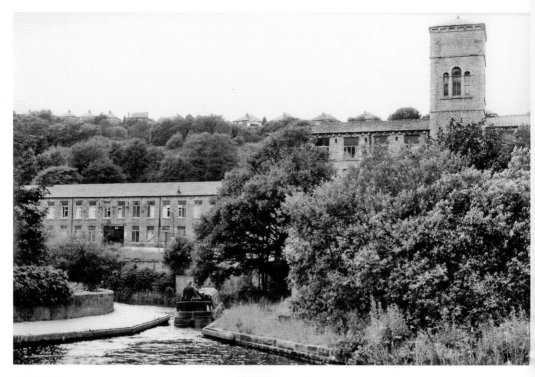

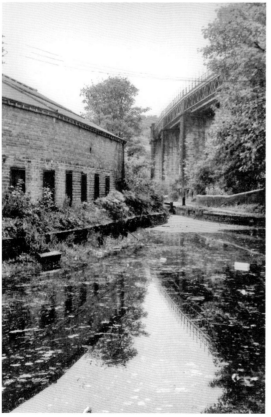

Above: Golcar Aqueduct,
Huddersfield Canal
This aqueduct spanned the River Colne
west of Milnsbridge. This aqueduct was
also known as Scarbottom. (*Ray Shill*)

Left: Paddock Aqueduct and Railway
Viaduct, Huddersfield Canal
The Colne was crossed again at Paddock
near Huddersfield. (*Ray Shill*)

Chapter Five
Railways and Railway Ownership

There were a diverse number of tramways that served navigations in the North. The Lancaster Canal incorporated a plateway into its route, linking the Southern Lancaster at Walton Summit with the north Lancaster at Preston. There was also a long tramway from the Gatebeck Powder Mills to the Lancaster.

Further north, the Carlisle Canal was converted into a railway by the owners who formed the Port Carlisle Railyway & Dock Company, which opened for traffic in 1854. This route was joined with another new line to Silloth, opened in 1856, and both railways were leased by the North British Railway in 1880.

The Carlisle Canal Basin also became the terminus of the Newcastle & Carlisle Railway, which became the first railway to cross England from west to east. With the railway completion in 1839, passengers and freight could make the journey between Newcastle and Carlisle, where transit was available along the canal to Port Carlisle.

Building railway routes across the Pennines faced equally harsh challenges as those making the canals a few decades earlier. The principal railways were the Manchester & Leeds, which passed through Todmorden and Hebden Bridge, crossing the Rochdale Canal, and which became part of the Lancashire & Yorkshire Railway network. Another route was the London & North Western Railway, who had absorbed both the Leeds, Dewsbury & Manchester and the Huddersfield Railway & Canal Company, and provided the route that followed the Huddersfield Canal from Stalybridge to Huddersfield. The decision for the Huddersfield Canal Company being integral to the scheme, when they decided to build a railway alongside the existing canal route, meant the canal was brought into railway ownership.

The Huddersfield Narrow Canal had passed into railway ownership following the amalgamation with the Huddersfield & Manchester Railway. In 1847, the canal and railway were taken over by the London and North Western Railway, who built a second single-track railway tunnel at Standedge parallel to the first. Increasing demand necessitated the building of a third double-track railway in 1894. This canal became part of the London, Midland & Scottish Railway with the railway grouping of 1921–23. An Act for formal abandonment of this canal was granted in 1944.

A third cross-Pennine route was owned by the Midland Railway. Their various acquisitions of the Leeds & Bradford, Leeds & Bradford Extension and the 'Little' North Western railways provided routes that crossed the Leeds & Liverpool Canal at various points. Another Leeds and Liverpool crossing was made by the Great Northern Railway, which had lines in the Leeds area but whose main focus was directed towards London.

The most notable canal-owned tramway in the Pennines was the line owned by the Leeds & Liverpool Canal and linked Haw Bank Quarries to the Springs Branch.

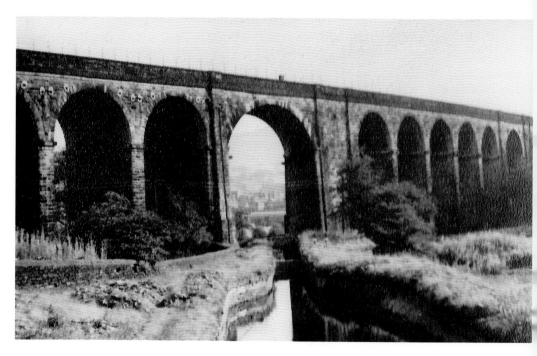

Saddleworth Railway Viaduct, Upper Mill, Huddersfield Canal, 1967 and 2003
Construction of the railway from Huddersfield to Manchester was started for the Huddersfield
Railway & Canal Co., and completed 1849 for the company that came to own the railway, the
London & North Western Railway. This route followed the canal closely and included a parallel
tunnel at Standedge. The climb from Stalybridge to Diggle has the Saddleworth Viaduct, which
spans the canal on twenty-three arches, three of which were built askew. The engineer responsible
for the construction was Alfred Stanistreet Jee (1816–58). He sadly lost his life at an enbankment
collapse in Spain. (*RCHS K. Gardiner Collection 67151 and Ray Shill 773166*)

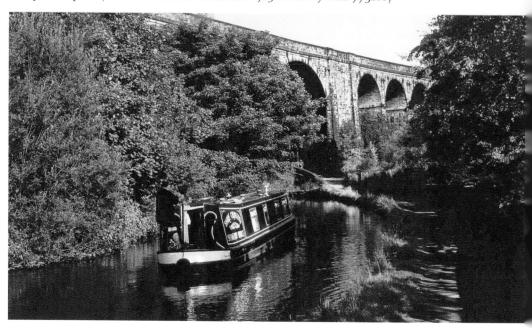

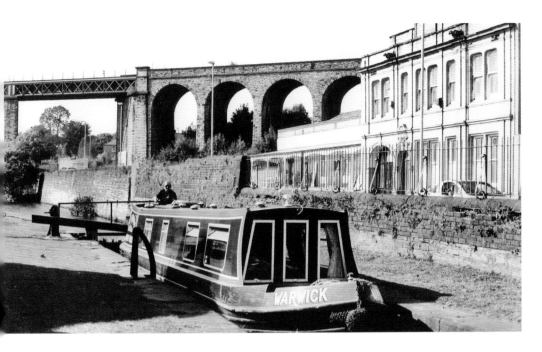

LYR, Railway Viaduct and Lock 4E, Huddersfield Canal, 2003
The Huddersfield & Sheffield Junction Railway, opened in 1850, spans the canal and River Colne at Paddock by a brick arch and girder viaduct. The railway formed a link between Huddersfield and Penistone and was part of the Lancashire & Yorkshire Railway network in the district. (*Ray Shill 774776*)

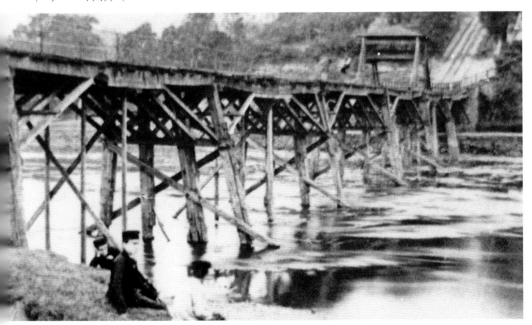

Lancaster Canal Tram Road, Crossing Over the River Ribble & Avenham Incline
The plateway crossed the Ribble along a wooden viaduct and then ascended a steep incline to reach Preston Basin. (*Preston Library 775005*)

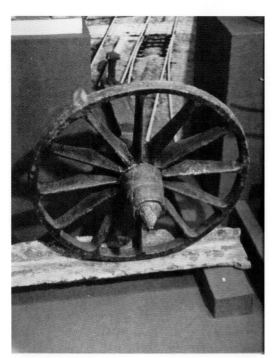

Left: **Tramway Wheel and Section of Plateway, Preston Museum**
The railway was built with three inclines Walton Summit, Penworthan and Avenham, and a wooden bridge over the Ribble. The wagons were drawn up at the inclines by steam engines. That at Avenham was supplied by John Wilkinson of Wrexham.
(*Ray Shill 775001*)

Below: **Thanet Canal Tramway, Skipton**
The tramway ran from the termination of the canal to the Earl of Thanet's Quarries at Haw Bank Rock. The canal company came to own this tramway, which carried limestone to the private canal branch.
(*RCHS Bertram Baxter Collection 21813*)

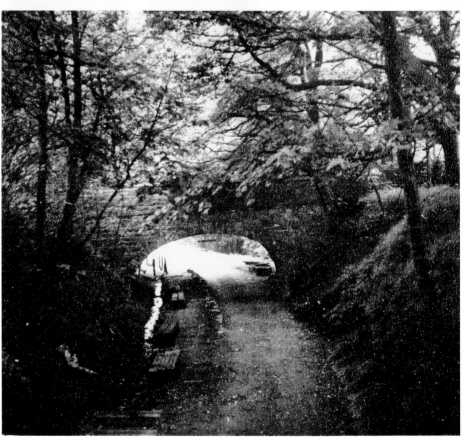

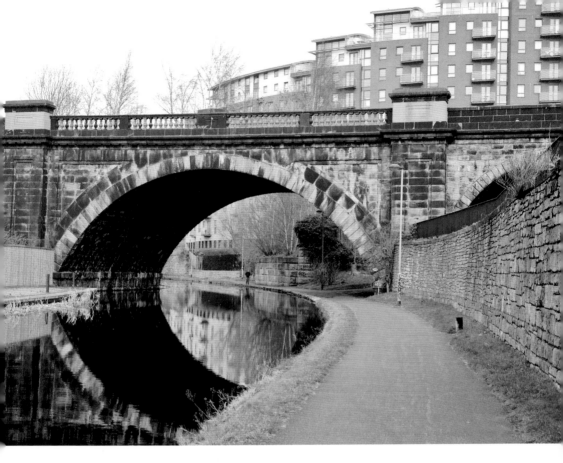

Leeds Central Line Railway Bridge, Leeds & Liverpool Canal

The railway line to Leeds Central Station was along an attractive stone aqueduct. This route was first opened during 1848, with Leeds Central being finished some two years later. Various companies used this line, including the Leeds & Thirk, London & North Western and the Great Northern Railway. Leeds Central was closed to passengers in 1967. (*Ray Shill 770056*)

Chapter Six
Nationalisation & Trusts

Nationalisation of the transport industries in 1947 only partially affected the northern waterways. The Docks & Inland Waterways Executive (D&IWE) inherited only one of the cross-Pennine routes. The route from Leeds to Liverpool, which formerly had been owned by the Leeds & Liverpool Canal Co., was still a commercial waterway, complete with warehouses along its course. It is a waterway that has remained intact, and since the use of residential and hire boating became popular, it has seen a resurgence in traffic. The only main change along the Pennine section has been the deviation of the canal at Bingley, which was required through road improvements.

Modern business, community, housing and retail developments have changed the use of features along the canal. These changes include the conversion of former warehouses at Skipton and Shipley, while at Leeds, major waterfront development have made vast changes to the canal side there.

The LMS had ceased to use the Huddersfield Canal and this route was abandoned for commercial craft in 1944 (although there was a requirement to maintain Standedge Tunnel). A part of the canal, east of Slaithwaite, was transferred to the Calder & Hebble Navigation. This last remaining working part of the narrow canal also became responsibility of the D&IWE from 1947. Pleasure craft continued to use the Huddersfield (Narrow) and there was also a requirement to supply water to the mills and factories along the canal. For administrative purposes, the DIWE designated the route of Huddersfield (Narrow), as from the Ashton Canal Junction, to Chapel Hill Bridge, Huddersfield (east of lock 3). The remaining part of the Huddersfield (Chapel Hill-Apsley Basin) was closed to commercial trade during 1963.

The Lancaster Canal was disused from 1947 and the transport act of 1955 authorised closure to navigation. Preston to Tewitfield and Glasson Dock were retained for use of pleasure craft.

Two important canal restorations were the Huddersfield and the Rochdale. The Huddersfield (Narrow) Canal, principally through the efforts of the Huddersfield Canal Society, began to be restored during the 1980s. Major obstructions included dropped bridges, where extensive engineering was required to alter the waterway course and reconstruct a suitable replacement bridge. New stretches of canal had to be made at Stalybridge, Slaithwaite and Huddersfield. All these jobs required civil engineering projects to ensure completion of the navigation.

The Rochdale reopening involved similar problems, some of which have already been mentioned in the Manchester volume. Most of the route of the Rochdale Canal became disused in 1952, and only the 'the Rochdale 9 Locks' section in Manchester remained in use. Much of the Rochdale Canal remained intact and parts between the summit and Sowerby Bridge were restored to navigation over a period of time. The last part being that at Tuel Lane, Sowerby

Bridge, which required a new, deep lock (the deepest in the country) to be constructed. Sections on the Manchester side of the summit did require further attention where bridges had been removed.

British Waterways, who succeeded the D&IWE as waterway owners, presided over the declining commercial trade and adapted the waterways under their control for the growing pleasure boating market. They also gained the responsibility for managing and maintaining the Huddersfield and Rochdale canals when they reopened (2001 and 2002 respectively). From July 2012, these duties passed to the Canal & River Trust, which replaced British Waterways in England and Wales.

A future restoration proposal is the return to navigation of the Bradford Canal. This scheme was first suggested during 2001, although there appears to be little prospect of the scheme proceeding at present. A principal difficulty is the fact that back pumping would be required to enable craft to pass the locks, as it did when this canal was reopened in 1872/73.

Outside of the control of the Canal River Trust (CRT) and British Waterways (BW) is the Preston Docks development. This is owned by the Port of Preston, whose responsibility included the Ribble Estuary. The closure of the docks for commercial traffic came about with the declining use of the docks. The development of the docks did create room for housing and retail facilities, including a new large supermarket complex. River pleasure craft still access parts of the dock complex.

The Pennine waterways are a visible reminder of British engineering's skill and achievement. Despite difficult odds, these waterways spanned difficult terrain to form a network of commercial waterways. Today, they are a national assest to be enjoyed by all that walk, cycle or boat along their length. Credit must also be given to those enginners employed by British Waterways and the many volunteers, whose combined efforts made possible the restoration of both the Huddersfield (Narrow) and Rochdale canals.

John Phillips, when describing the Leeds & Liverpool Canal in his 1792 *A General History of Inland Navigation, Foreign and Domestic*, states 'Works of genius generally draw the attention of men of genius'. Here, Phillips was talking specifically about the engineer John Longbotham, but it is a sentiment that applies to a number of people whose skill and experience created all the transport lines across the Pennines, be it the canals, railways or turnpike.

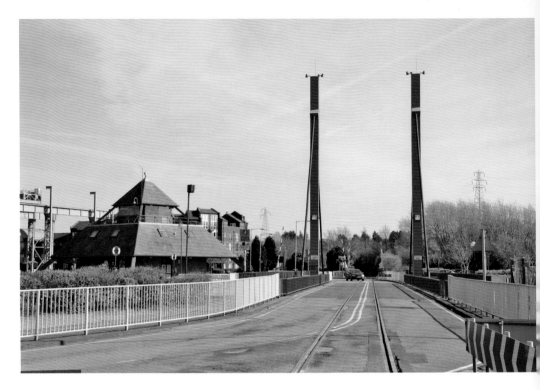

Bridge, Port of Preston
With the closure of Preston Docks for commercial traffic, the road crossing over the access to the main basin was replaced by a pedestrian, road and rail bridge. The rail traffic was retained to access an oil depot, although previously had also served works belonging to English Electric. (*Ray Shill 836905*)

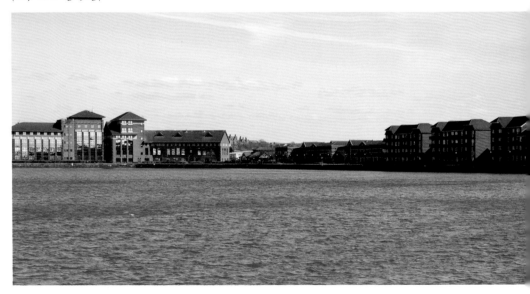

Albert Edward Docks, Preston
These docks were opened in 1892. (*Ray Shill 836925*)

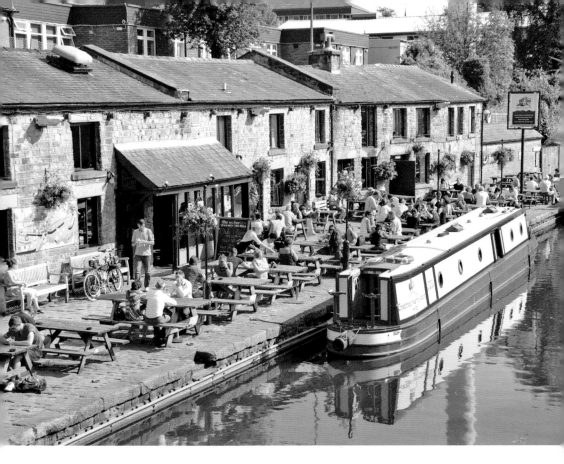

The Water Witch Public House, Lancaster, Lancaster Canal
A modern view of the canal at Lancaster, where heritage buildings have found a new use. The name 'Water Witch' commemorates the horse-drawn packet boat that ran along the Lancaster Canal from Preston. (*Ray Shill 775810*)

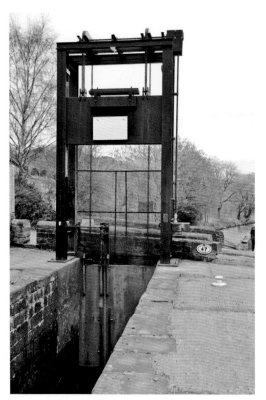

Upper Mill (or Shuttle Lock, 24E), Slaithwaite, Huddersfield Narrow Canal, 2003 and 2014
Lock 24E has an unique feature. It is has a guillotine gate instead of two mitre gates for the lower or bottom gate arrangement. The closeness of the lock to Bridge 47 has neccessitated the use of the guillotine gates. These gates were affected, however, by the corrosion of parts of the mechanism used to raise and lower the gate. CRT has closed this part of the canal while the affected parts were being replaced.
(*Ray Shill 774128*)

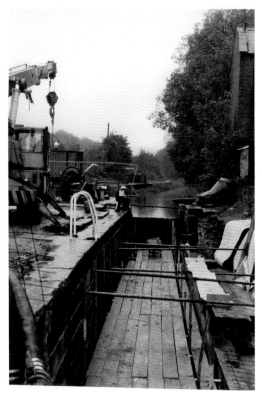

Lock Restoration, Huddersfield Canal
A lock near Slaithwaite under restoration.
(*Ray Shill 774115*)

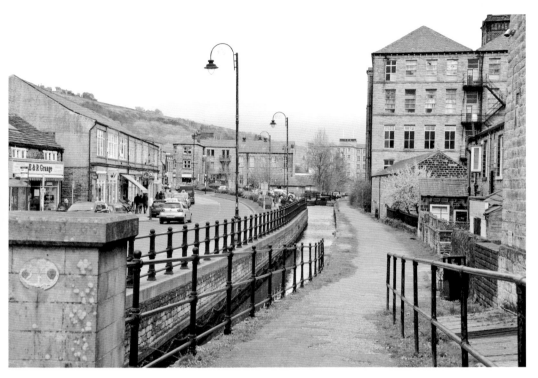

Above: **Slaithwaite, Huddersfield (Narrow) Canal**
The canal was infilled, roads widened and the remainder grassed over. During 2000, the new canal route was excavated as a narrow channel, but was wide enough to permit narrow boats and barges to pass through. (*Ray Shill 774195*)

Right: **Site of Original Lock 21E, Huddersfield Narrow Canal**
The east chamber of the former lock 21 was opened out for the relocation of the new lock north of Platt Lane Bridge. (*Ray Shill 774238*)

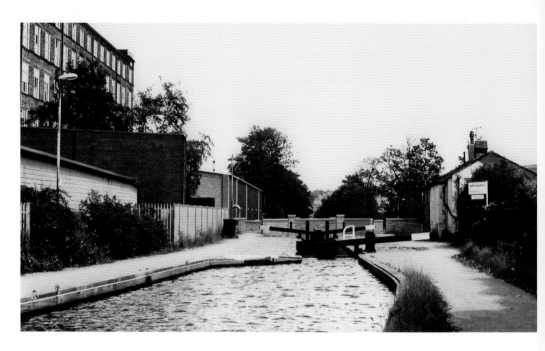

Lock 21E, Slaithwaite, Huddersfield Canal
The new lock 21E was constructed east of Platt Lane and avoided the need to raise the road when the modern bridge was constructed. (*Ray Shill 774231*)

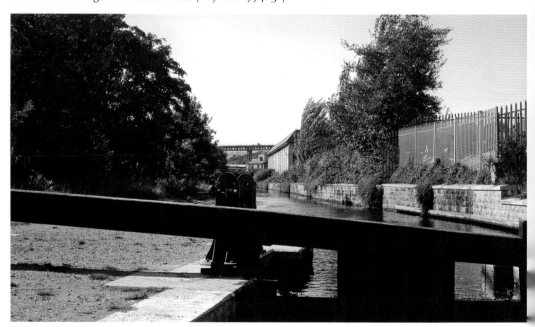

Lock 3E, Huddersfield Canal
With the reopening of the Huddersfield Canal, a new lock was built west of the original canal lock at Chapel Hill Bridge. This new concrete-lined lock (2001), in common with other new locks on this navigation, had the ground paddles at the head of the lock on the same side. (*Ray Shill 774842*)

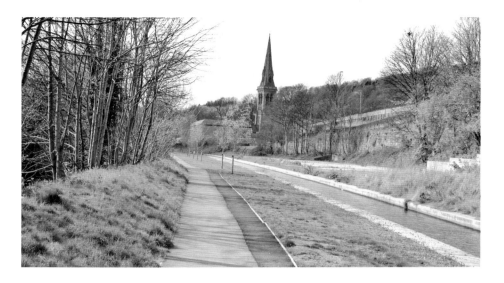

Site of Sellers Tunnel, Huddersfield, Huddersfield Canal
The restoration of the Huddersfield Canal required the relocation of lock 3 further west and away from Chapel Hill Road Bridge, near where it was originally located. The 'new' lock was opened in 2001, when Sellers Tunnel was ready for traffic. This tunnel passed under the Sellers engineering works, through the chamber of the original lock 3. The tunnel was 355 yards long. Following the move of Sellers & Co. to new premises, which made way for the Waterfront Scheme, the engineering premises were demolished. The new channel and modern towing path retain the level from Longroyd Bridge to Kirklees College. (*Ray Shill 774861*)

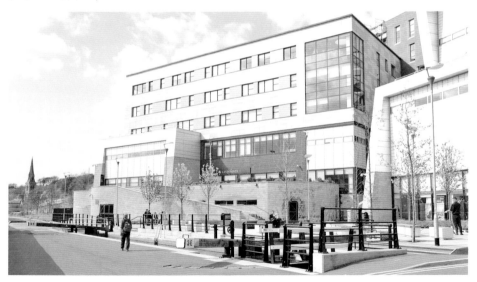

Lock 3E, Huddersfield, Huddersfield Canal
This lock is the newest on the Huddersfield Canal. It was completed during 2012 and in the last months of the existing government-owned British Waterways in England. This lock replaced lock 3E of 2001, which was placed at the west end of Sellers Tunnel. The change came about through the Waterfront Scheme, which included the building of Kirklees College, whose buildings are seen alongside this lock. (*Ray Shill 774895*)

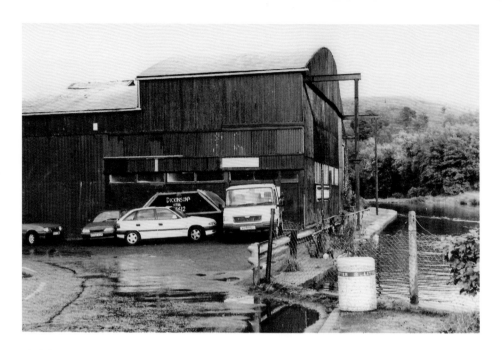

Littleborough Wharf, Rochdale Canal
Corrugated iron forms the framework of the Rochdale Canal Depot at Littleborough. This location was also the terminus of the navigation in water from Sowerby Bridge, although craft turned round at the summit. (*Ray Shill 839428*)

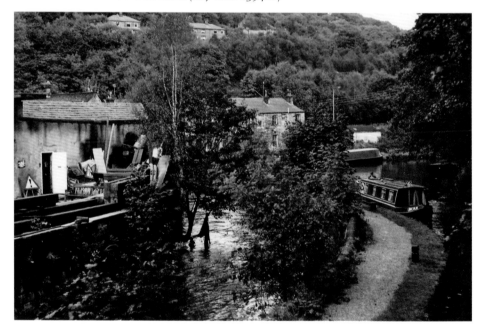

Callis Mill, Rochdale Canal
The Rochdale Canal restoration scheme had a workshop at Callis Mill, where lock gates were constructed. They also supplied gates to other canals, but once the Rochdale Canal was fully opened, orders dwindled and the workshops were closed.

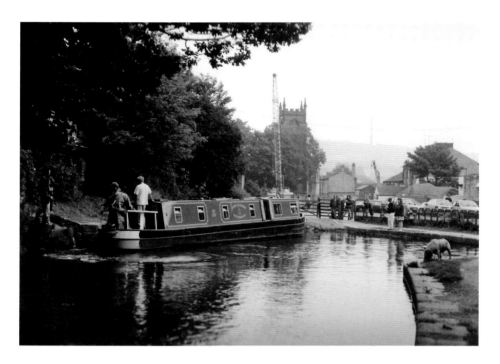

Sowerby Bridge Temporary Terminus
During the 1990s, the Rochdale Canal had a navigable section from Hebden Bridge to Sowerby Bridge, with a winding hole at Sowerby. (*Ray Shill 836681*)

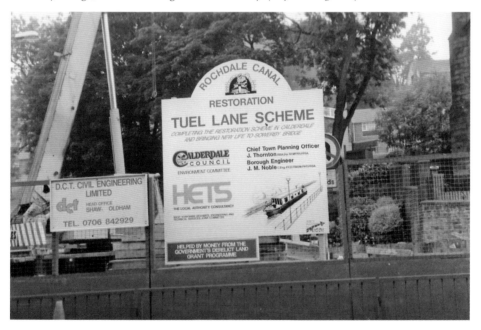

Sowerby Bridge Lock 3 and 4 Reconstruction
The widening of Tuel Lane at Sowerby Bridge, after abandonment, created an engineering problem for restoration. With restoration of the navigation, it was decided to combine lock 3 and 4 as a deep lock with 19 feet 8½ inches rise. (*Ray Shill 836706*)

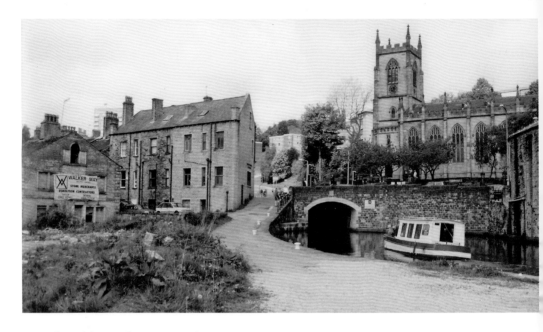

Sowerby Bridge Tuel Lane Tunnel
The tail of lock 3 was placed under the road bridge. Following the abandonment of the canal, locks 3 and 4 were buried under a new road, and with restoration the Deep Lock was moved north of this road. The former lock chambers were converted to form part of a tunnel under the roads. Access to the deep lock at Tuel Lane from lock 2 is now through Tuel Lane Tunnel (114 yards). (*Ray Shill 836714*)

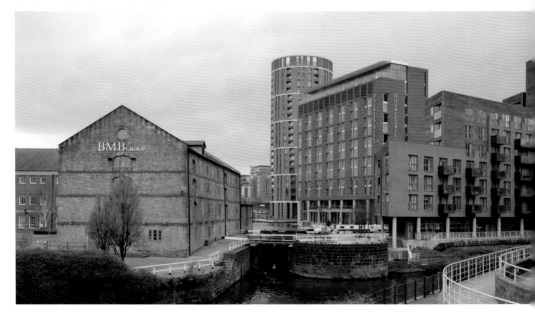

Lock 1, Leeds, Leeds & Liverpool Canal, 2014
The waterfront where the Leeds & Liverpool Canal joins the River Aire, and is the start of the Aire & Calder Navigation, has been transformed within the last decade with office blocks and retail development. (*Ray Shill 770076*)

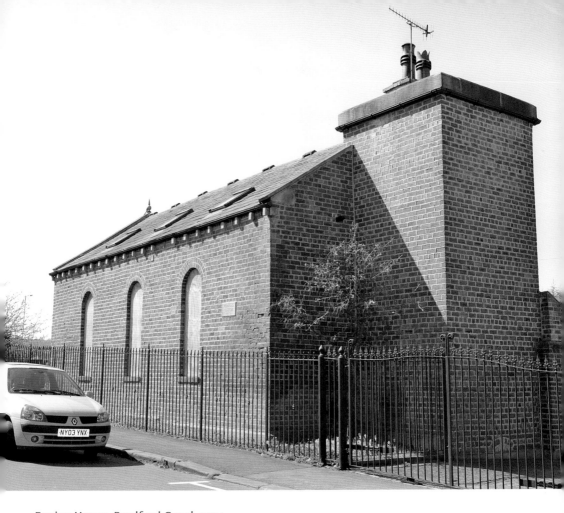

Engine House, Bradford Canal, 2014
The former engine house at Windhill, Shipley, is placed alongside the first lock on the Bradford Canal. If the canal is restored, the route would pass this building on the opposite side. Both this building and the adjacent lock house are now private residences. (*Ray Shill 771105*)

Notable Features of Northern Canals

Grid references are quoted for locations

Bradford Canal

Windhill Lock & Engine House	SE153376
Pricking Mill Staircase (2)	
Crag End Staircase (3)	
Oliver Staircase (2)	
Spink Well Staircase (2)	
Northbrook Street (Zetland Mill) Basin	
Hoppy Bridge Basin (site)	SE166333

Carlisle Canal

Carlisle Basin & Warehouse	
Port Carlisle Sea Lock	NY241622
Reservoir (filled in)	
River Eden Feeder & Pumping Station	

Huddersfield (Narrow) Canal

12 Mile Lock (26W)	SD997067
Ashton Lock (1W) & Horse Tunnel	SJ941986
Avenue Lock (10W)	SD974004
Bank Nook Lock (30E)	SE062131
Bates Tunnel (100 yards)	SE145160
Black Rock Lock (9W)	SD974003
Booth Lock (31E)	SE060127
Bywith Lock (8W)	SJ974996
Cas Lock (18E)	SE093146
Cast Iron Lock (29W)	SE000069
Cellars Lock (34E)	SE054122
Coal Wharf Lock (2E)	SE145160
Coffin Lock (27W)	SD997067
Colne Lock (38E)	SE052119
Dartmouth Lock (23E)	SE077138

Dirker Lock (41E)	SE048118
Division Lock (17W)	SD982035
Dobcross Lock (30W)	SE001070
Dungebooth Lock (22W)	SD987062
Embankment Lock (28W)	SD999067
Fountain Lock (7E)	SE127159
Gasworks Lock (16W)	SD982034
Geoffrey Dickens Lock (31W)	SE002073
Golcar Aqueduct (34)	SE107157
Golcar Brook Lock (15E)	SE099151
Hall Lock (20W)	SD995050
Highest Westwood Lock (17E)	SE096146
Holme Lock (19E)	SE090145
Hopper Lock (40E)	SE050118
Isis Lock (9E)	SE123159
Keith Jackson Lock (18W)	SD983039
Library Lock (11E)	SE120158
Lime Kiln Lock (23W)	SD987064
Longroyd Bridge Lock (4E)	SE136162
Lowest Westwood Lock (16E)	SE098148
Mark Bottom Lock (6E)	SE132160
Mill Pond Lock (27E)	SE067134
Moorvale Lock (35E)	SD053121
Navigation Lock (25W)	SD996066
Paddock Aqueduct (28)	SE134162
Paddock Foot Lock (5E)	SE134162
Pickle Lock (22E)	SE082141
Pig Tail Lock (32E)	SE056125
Plantation Lock (2W)	SJ947984
Railway Aqueduct (74)	SD987064
Railway Lock (42E)	SE046118
Ramsden Highest Lock (14E)	SE102153
Ramsden Lowest Lock (13E)	SE105154
Reservoir Overspill Bridge 63	SE040120
Roaches Lock (15W)	SD982032

Roller Lock (8E) SE124159
Rough Holme Lock (12E) SE112157
Royal George Aqueduct (84),
Greenfield SD983037
Royal George Lock (19W) SD984041
Saddleworth Aqueduct (67) SE002072
Scout Tunnel (205 yards) SD973011
Sellars Lock (2001, 3E) SE140162
Original Lock (3E) SE143161
Sellars Lock (2012, 3E) SE142161
Sellars Tunnel
(355 yards, W–E) SE140162–
 SE143161
Shaker Wood Lock (25E) SE073135
Shuttle Lock (24E) SE076137
Skewbridge Lock (26E) SE069134
Smudgees Lock (37E) SE053119
Sparth Lock (33E) SE054125
Spot Lock (20E) SE087414
Spring Garden Lock (10E) SE122158
Stalybridge Locks
(4W–7W, W–E) SJ961983–
 SJ967987
Standedge Tunnel
(5,686 yards, W–E) SE005079–
 SE040120
Stanley Dawson Lock (1E) SE148163
Summit Lock (32W) SE003077
Tame Aqueduct (105),
Stalybridge SJ953983
Tarne Lock (3W) SJ948984
Terrace Lock (11W) SD973008
Uppermill Viaduct (76) SD987063
Wade Lock (21W) SD986055
Waring Bottom Lock (28E) SE066133
Warehouse Hill Lock (39E) SD051118
Waterside Lock (21E) (new) SE083142
Lock 21E (old) SE081142
Wharf Cottage Lock (13W) SD976023
Whitehead's Lock (12W) SD975013
White Hill Lock (29E) SE064132
White Sky Lock (36E) SD053119
Woodend Lock (14W) SD977025
Wool Road Lock (24W) SD997067

Reservoirs (10)

Black Moss (N–S) SE032088–SE034086
Brun Clough Compensation SE029105

Diggle (N–S) SE022083–
 SE022082
Little Black Moss SE033086
March Haigh (N–S) SE017131–
 SE016128
Red Brook SE027096
Slaithwaite (N–S) SE076142–
 SE076141
Sparth SE055125
Swellands (N–S) SE038092–
 SE038089
Tunnel End SE040121

Lancaster Canal

Main Line

Ashton Basin, Preston SD521308
Bolton Turnpike Bridge 123 SD485680
Brock Aqueduct 46 SD509403
Bulk Road Aqueduct 106 SD487636
Calder Aqueduct 52 SD507434
Capernwray Arm SD528724
Cocker Aqueduct 82 SD487527
Condor Aqueduct 87 SD478552
Garstang Turnpike Bridge 59 SD495445
Glasson Branch Junction SD482545
Hest Bank Swing Bridge 120 SD473669
Hollowforth Aqueduct 38 SD508363
Hollowforth Swing Bridge 37 SD504362
Keer Aqueduct 132 SD530719
Lune Aqueduct 107 SD483638
Preston Terminus (BW)
& Ashton Basin SD527303
Preston Basin (original site) SD535293
Savik Aqueduct 13 SD518312
Woodplumpton Aqueduct 33 SD493354
Wyre Aqueduct 61 SD490448

Glasson Branch

First Lock SD481545
Second Lock SD477544
Third Lock SD473543
Fourth Lock SD467546
Fifth Lock SD463552
Thurnham Mill SD461555

Sixth Lock, Thurnham Bridge	SD461554
Glasson Basin	SD446559
Swing Bridge and Lock	SD445561

Northern Reaches (Tewitfield–Kendal)

Tewitfield Locks 1–8 (N–S)	SD521748–SD521738
Burton Road Aqueduct 144	SD523769
New Mill Aqueduct 145	SD523773
Farleton Beck Aqueduct 160	SD538817
Gatebeck Tramway Wharfs	SD544835
Feeder (Killington Lake) outlet from Peasey Beck	SD541843
Feeder (Killington Lake) outfall, Crooklands	SD544835
Crooklands Aqueduct (Peasey Beck) 165	SD544836
Stainton Aqueduct (Stainton Beck) 171	SD523854
Hincaster Tunnel (W–E)	SD509851–SD514851
Sedgwick Aqueduct 178	SD514870
Natland Beck Mill & Aqueduct	SD518908
Kendall Basin	SD511926

Reservoir

Killington Lake dam (W–E)	SD589907–SD592907

Tram Road

Avenham Incline	SD541287
Penwortham Incline	SD543273
Preston terminus	SD535293
Tramway Bridge over Ribble	SD541286
Walton Summit Incline	SD565254

Leeds & Liverpool Canal

Apperley Bridge Depot	SE188382
Bank Newton Locks (36–41, N–S)	SD914534–SD912529
Bank Newton Canal Workshops	SD913533
Barrowford Aqueduct	
(Colne Water)	SD866394
Barrowford Locks	SD869403–
(45–51, N–S)	SD868396
Bingley Five Rise (60ft) (29–25)	SE106400
Bingley Three Rise (29 feet 11 inches) (22–24)	SE107394
Bradford Beck Aqueduct	SE152377
Bradford Canal Junction & Bridge 208	SE153377
Dobson Locks (2 rise 23 feet 9 inches) (15–14)	SE188382
Double Arches Bridge (161), East Marton	SD909508
Dowley Gap Aqueduct	SE123383
Dowley Gap Locks (2 rise, 18 feet 4 inches) (21–20)	SE119383
East Marton Warehouse	SD909507
Eller Beck Aqueduct, Skipton	SD986515
Field Locks (3 rise, 25 feet) (18–16)	SE180397
Forge Locks (3 rise, 23 feet 10 inches) (10–8)	SE251364
Foulridge Tunnel (1640 yards, W–E)	SD875416–SD887424
Foulridge Wharf and Warehouse	SD888425
Gargrave Locks (35–31, W–E)	SD918539–SD943544
Gargrave Warehouse & Coal Wharf	SD935546
Greenberfield Locks (42–44, W–E)	SD887482–SD889485
Hirst Lock (19)	SE132383
Holme Bridge Aqueduct (Eshton Beck)	SE942545
Kildwick Aqueduct	SE009459
Kirkstall Lock (7)	SE257358
Midland Railway Viaduct, Foulridge (site)	SD888426
Midland Railway Viaduct, Gargrave	SD918539
Nelson Warehouse	SD956381
Newlay Locks (3 rise, 26 feet 11 inches) (13–11)	SE243367
Oddy Locks (2 rise, 13 feet 7 inches) (4–5)	SE286335
Office Lock (2), Leeds	SE295331

Priest Holme Aqueduct, River Aire SD918538
River Lock (1) & Warehouse, Leeds SE297331
St Ann's Ing Lock (3) SE290333
Silsden Beck Aqueduct, Silsden SE043362
Shipley Warehouse SE149376
Skipton Warehouse SE993521
Stockbridge Warehouses,
Riddlesden SE076422
Spring Garden Lock (6) SE284337
Whitemoor Reservoir Outfall SD886439

Reservoirs

Barrowford Reservoir SD870402
Foulridge (Lower) Reservoir SD880419
New or Foulridge (Upper)
Reservoir SD891414
Slipper Hill Reservoir SD876422
White Moor Reservoir (N–S) SD878435–
 SD878429
Winterburn Reservoir and SD941602–
Feeder (W-E) SD945602

Leeds & Liverpool Canal (Leeds & Armley Navigation)

Arches (Monks Pit) Lock, Leeds SE296333

Rain Hall Rock Quarry Canal

Tunnel (1) SD885468
Tunnel (2) SD891472
Quarry SD891474

River Lune

Glasson Dock SD443562
Lancaster Quays SD467623

River Ribble

New Diversion Quay SD524293
Preston Docks Bridge SD510295
Preston Docks SD506294–
(Albert Edward, W-E) SD520296
Victoria Wharf (site) SD525294

Rochdale Canal

Bent House Lock (46) SD944168
Blackpit Lock (9) SD997267
Bottomley Lock (33) SD940208
Brearley Upper Lock 6 SE028259
Broadbottom Lock (7) SE007264
Callis Lock (13) SD977267
Durn Lock (47) SD943165
Edward Kilner Lock (5) SE030257
Ellen Royd Aqueduct SE037251
Gauxholme Locks SD930233–
(22–24, N–S) SD930230
Gauxholme Viaduct SD930232
Gauxholme Warehouse SD930233
Hebden Bridge Aqueduct SD991271
Hollings Lock (27) SD933223
Holmcoat Lock (14) SD968261
Sowerby Bridge Junction SE067237
Library Lock (19) SD937243
Lightbank Lock (31) SD938213
Littleborough Bottom Lock (48) SD941163
Lobb Mill Lock (16) SD963262
Longlees Lock (36) SD945199
Mayroyd Mill Lock (8) SD999266
Moss Lower Lock (50) SD904124
Moss Upper Lock (49) SD906125
Nip Square Lock (29) SD935217
Old Royd Lock (17) SD955246
Pike House Lock (45) SD945173
Pinnel Lock (26) SD932226
Punchbowl Locks SD945179–
(40–42, N–S) SD945177
Rawden Mill Lock (12) SD978278
Sands Lock (32) SD940210
Shade Lock (21) SD931234
Shawplains Lock (15) SD964254
Shop Lock (18) SD938243
Sladen Aqueduct SD945174
Sladen Lock (44) SD945175
Smithyholm lock 25 SD932227
Sowerby Bridge Locks SD063236–
(1–2, W–E) SD064236
Stubbing Locks SD985272–
(11–10, W–E) SD986272

Todmorden Warehouse (site) SD936243

Tuel Lane Lock,
(19 feet 8½ inches) (3&4) SD061237

Tuel Lane Tunnel (114 yards) SD062237

Thickone Lock (43) SD945176

Travis Mill Lock (28) SD935219

Warland Lower Lock (34) SD944203

Warland Upper Lock (35) SD945202

Wadsworth Mill Lock (20) SD932235

West Summit Locks SD946183–
(37–39 N–S) SD945180

Whiteley Arches Viaduct SD982270

Winterbutlee Lock (30) SD916215

Rochdale Branch

Junction with main line SD903124

Rochdale Canal Wharf (site) SD899127

Reservoirs (8)

Blackstone Edge SD967183

Gaddings Dam SD952223

Higher Chelburn SD953185

Lower Chelburn SD949187

Hollingworth SD940151

Light Hazzles SD963206

Warland SD954214

White Holme SD973203

Springs Branch (Lord Thanet's Canal)

Junction with Leeds & Liverpool SD992521

Terminus of Branch SD996527

Ulverston Canal

Canal foot and lock SD313776

Ulverston Basin SD294785